In the same series

Musée d'Orsay
Paris

© 1994 Éditions Scala
14 bis, rue Berbier du Mets - 75013 Paris

SELECTED WORKS

The Louvre

Anette Robinson

in collaboration
with Isabelle Bréda

Translated by Bambi Ballard

EDITIONS
SCALA

A note to the reader

No one needs a book to tell them how to enjoy a painting. We are instinctively touched by a smile, dazzled by a colour, impressed by a subject. We like or do not like a painting.
But once the first impression is over, questions arise, and that is when we need some explanations.

Is it not more enriching to understand the technique of *sfumato* when admiring the sweet mysterious smile of the *Mona Lisa*, or to know that the reason portraiture came to the forefront in the 16th century is because of the development of Humanism, which led to the recognition of the importance of the individual?
Is it not more fun to decipher Baugin's *Still life with chessboard* armed with a knowledge of the symbolic meaning of a carnation, a mirror or a mandola?
 Questions do not arise spontaneously, of course, but as soon as we are in possession of a few notions of art they multiply rapidly. The answers are quite straightforward, and a dozen paintings can serve as a guide to the basic rules and enrich our appreciation of painting in all its diversity.

This has been the guiding principle in the conception of this book, which is laid out as follows:
The opening pages have been devoted to the history of the museum itself.
Next, the subjects, the painting techniques, and the historical context of the twelve selected paintings are analyzed in detail.
These are interspersed with six chapters dealing with the style or school to which the paintings belong and its development.
At the end of the book a series of annexes provides some indispensable information:
— a chronological chart that places the paintings discussed in this book in context with other works in the museum,
— biographical notes on each of the painters,
— a glossary of the principal technical terms.

Victor Chavet
The Louvre at the time of Napoleon III
(1857).
Whereas the kings of France had
wanted the Louvre to be a luxurious
pleasure palace, it was Emperor
Napoleon III who set in motion the
grand design of uniting the Louvre with
the Tuileries palace (foreground), and
transforming it into a marvellous
Palace of the Arts. Unfortunately, the
Tuileries palace was burnt down in
1871, during the uprising of the
Commune.　▶

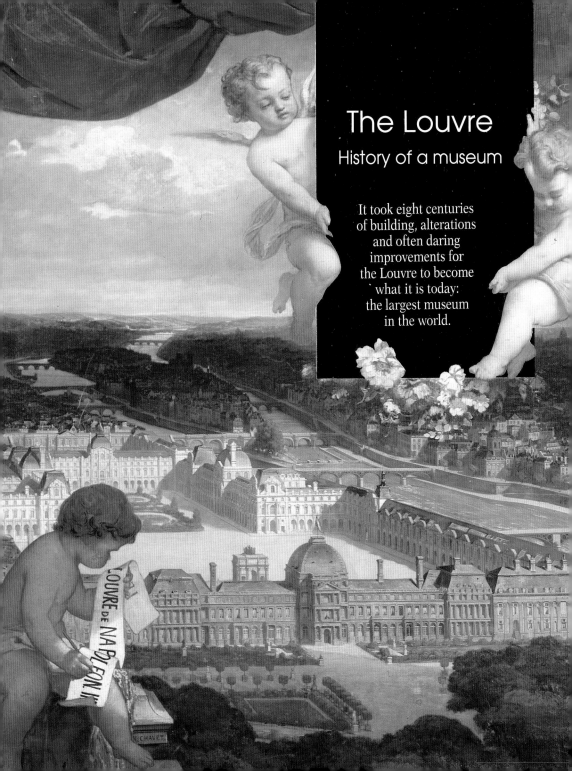

The Louvre
History of a museum

It took eight centuries
of building, alterations
and often daring
improvements for
the Louvre to become
what it is today:
the largest museum
in the world.

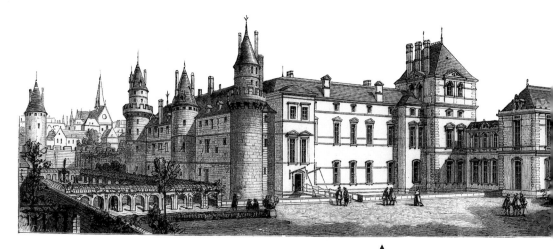

The vocation of the Louvre to be a "Palace of the Arts" is not a new one. Originally designed as a fortress, the Louvre became a palace during the reign of Charles V of France (1364-1380), but it already functioned as an archive, housing the king's illuminated books. He installed a "library" in the north-west tower for his collection of 973 manuscripts which form the basis of what is now the National Library. His descendants found the Louvre so gloomy that they decided to alter it into a pleasure palace, and a number of kings displayed their art collections there. It wasn't until the reign of Henry IV (1589-1610) that the project of demolishing the fortress and linking the old palace to the new Tuileries palace was broached. There were to be major alterations and building of galleries and workshops: the artistic vocation of the Louvre had been born.

Restitution of the North and West façades of the Louvre circa 1610. Anonymous 19th-century engraving.

Grand design for the Louvre as Henry IV would have wished it. Anonymous painting of the 17th century.

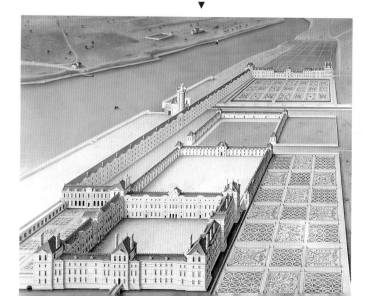

The "king's workmen", painters, sculptors, goldsmiths and weavers, moved in with their families, kept shops and produced some of the most beautiful artefacts of the period. However, Henry IV only lived to see the building of "the large gallery on the waterfront" in which he installed his collection of antiquities, the first acquisitions of the future museum.

During the reign of Louis XIV, royal plans for the Louvre came to an abrupt end when the king abandoned Paris for Versailles. However, he did leave the royal collections

View of the courtyard of the Louvre, detail. Anonymous engraving.

In the 17th century, the Louvre was invaded by all sorts of parasites. Shanties and workshops proliferated in the Cour Carrée, and the idlers pressed through the gates and covered walks designed by Soufflot, to stroll amongst the engravings and paintings.

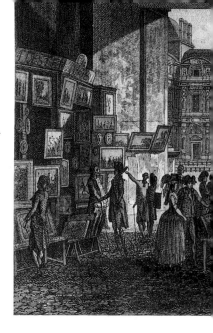

behind in the "Gallery of the King's paintings". The building was left in the hands of various academies, including the Royal Academy of Painting and Sculpture. It was under its auspices that the first exhibition of the work of its members was held in the Louvre in 1699. From 1725, the exhibitions were held in the Salon Carré, hence the use of the name "Salon" for

these annual shows that were to become so famous. The hanging of the paintings was extremely complicated, the object of the exercise being to cover every inch of the walls. The better known painters got the best places on the walls, at eye level. Sculptures and busts were displayed on tables. Diderot tells us in his book, *Salons,* that they were often rowdy affairs. As soon as the paintings were hung the guests elbowed their way in and the artists exchanged virulent criticisms at the tops of their voices. Diderot was one of the first to call for a museum that was open to more than the privileged few.

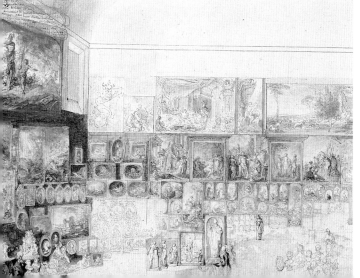

◀ **Saint-Aubin**, *The Salon at the Louvre in 1767.* Watercolour.

9

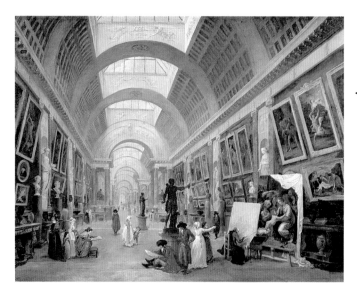

◀ **Hubert Robert**, *Project for the redecoration of the Grande Galerie* (Exhibited at the Salon of 1796). Oils on canvas.

régime fell before the task could be completed. The revolutionary government pursued the project however, and on 10 August 1793, the Museum opened its doors to the citizens of the Republic, displaying works from the royal collections, now

Neither Louis XV nor Louis XVI objected to Diderot's suggestion, and a committee was formed to organize the future museum, make the inventory and design the interiors and lighting. The painter Hubert Robert, an active member of the committee, came up with a number of ideas such as the one shown above, for the Grande Galerie, with natural light entering through vast glass roofing. But the *ancien*

Benjamin Zix, *Vivant Denon amidst the* ▶ *trophies of the Napoleonic campaigns.* Wash.

Made director of the future "Musée Napoléon" in 1802, Denon was also a painter, engraver, draughtsman and writer. At the fall of the Napoleonic Empire he was so upset at the restitution of the masterpieces to their rightful owners, that he resigned.

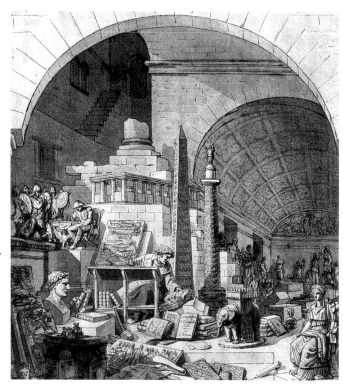

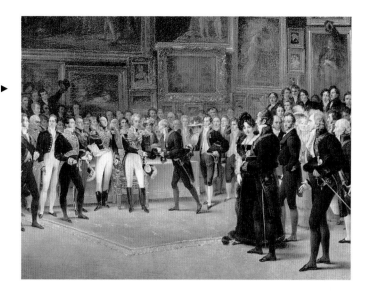

François-Joseph Heim, *Charles X distributing prizes to the artists on 15 January 1825*, detail.

become national collections, and works confiscated from the clergy and the *émigrés*.

From 1797, Napoleon added the booty from his Italian campaigns to these works, inaugurating a gallery of antiquities. The Louvre, renamed "Musée Napoléon" in 1803, was to be filled with over 5 000 works seized during the Napoleonic wars. Considering that those treasures deserved a better setting, the Emperor threw out the artists, revived Henry IV's plans and began building new galleries. Then came Napoleon's defeat in 1815, and the victorious states took back

their property. Four-fifths of the museum's collection left Paris for good.

During the Restoration, the "royal museum" was restocked with purchases, donations and works brought back by scientific expeditions. Salons continued to be held there, and in 1824 Charles X attempted to revive the traditions of the *ancien régime* by bestowing medals and commissioning paintings. The last Salon to be held at the Louvre before moving to the Luxembourg Palace took place in 1850. From then on the Museum ceased to show "living art" and concentrated on the "art of the past".

◀ **Auguste Biard**, *Four o'clock at the Salon, We're closing* (1847), details. ▶

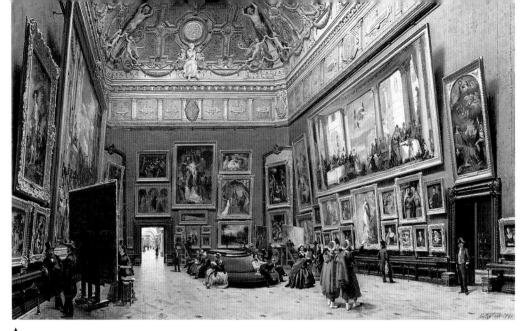

▲ **Giuseppe Castiglione**, *The Salon Carré of the Louvre* (1862).

Emperor Napoleon III resurrected the grand design for the Louvre. In the space of 5 years, 3 000 workmen made extensive additions and, even though the majority of the new buildings were used for the administration of the nation, the museum gained space. The ever-increasing public was at last able to move freely around the galleries. From 1855 the Louvre was opened to the public on weekdays. Up to then only artists and copyists had been admitted. Works of art became major family attractions: every day thousands of people streamed past the *Mona Lisa*, the *Venus de Milo,* or the *Winged Victory*. The Louvre no longer had to

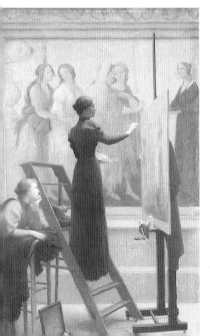

◄ **Étienne Azambre**, *Two women copying the Botticelli fresco* (1894).

seek an identity, the museum had finally won out over the palace.

Improvements to the Louvre were continued throughout the 20th century, but despite that, works began to pile up in the reserves and more space was desperately needed. The press began to campaign for the removal of the Ministry of Finance from the Richelieu wing to other premises as far back as the end of World War II, but the battle was not won until 1981, when President Mitterrand decided that all the wings of the Louvre were to be part of the museum. After a decade of work, the last section of the new "Grand Louvre", the Richelieu wing, was opened to the public in November 1993.

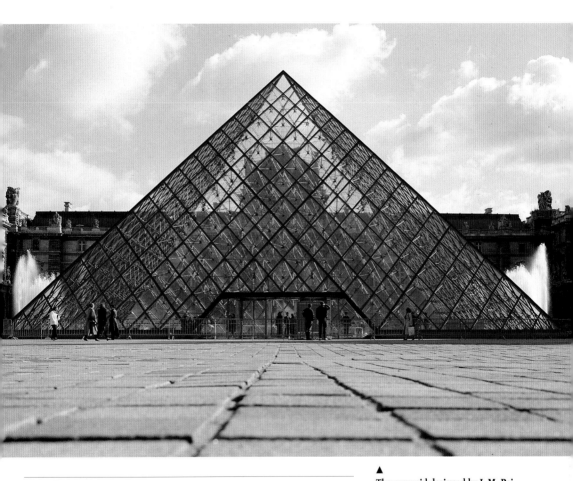

The Louvre in numbers

Covering a surface of 60 000 m², the 7 departments of the Louvre are arranged on 4 levels. They house 5 555 sculptures, 15 000 *objets d'art*, 16 000 paintings, 47 900 Greek and Roman antiquities, 50 000 Egyptian antiquities, 80 000 Oriental and Islamic antiquities, and 173 000 engravings and drawings. These masterpieces are protected by 650 guards and admired by an ever increasing number of visitors (over 5 million in 1993).

▲

The pyramid designed by I. M. Pei.
Inaugurated in Spring 1989, the glass pyramid stands in the centre of the Cour Napoléon. Its 612 glass lozenges cover the entrance to the renovated "Grand Louvre". The alterations made to the Louvre have provided more space for the collections, while the new entrance has practically eliminated queuing and made it easier for the public to find their way round the museum itself.

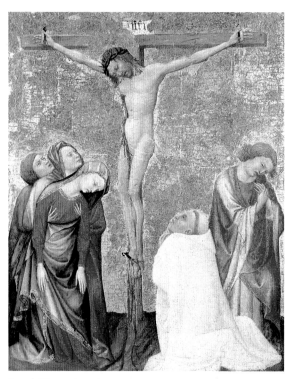

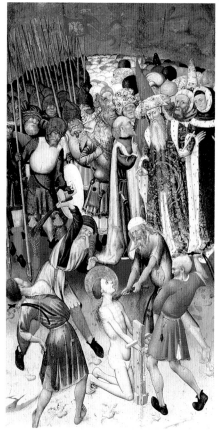

Jean de Beaumetz ▲
(1361?-1396).
Crucifixion with a
Carthusian monk
(1389/95?).
Oils on wood:
60 x 48,5 cm.

In France, painters
began to concentrate
on facial expression
and body movement
very early on.

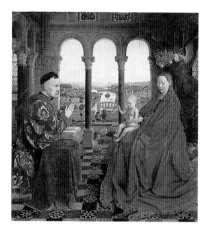

Jan Van Eyck ►
(1390/1400?-1441).
The Madonna of
Chancellor Rolin
(*c.* 1435).
Oils on wood:
66 x 62 cm.

Flemish painters
represented the real
world in great detail,
even in religious
paintings.

Bernardo Martorell ▲
(1427?-1452?).
The Flagellation
of St George (*c.* 1435).
Oils on wood:
107 x 53 cm.

St George inspired
many artists. This
sombre, melancholy
painting is typical of
Spanish painting,
which sometimes
appears cruel.

Religious painting

The earliest paintings of the Middle Ages to have survived portray Biblical scenes. In order to fully understand their meaning, it is essential to know something about the Christian religion and about life in Medieval times.
13th and 14th century life was dominated by religion. An ordinary, individual man was of little importance. He only really "existed" united with other men in the Church.

Medieval society was generally uneducated, learning was reserved for a few privileged people, and the mass of the population could neither read nor write. But it did understand pictures, and pictures were mainly to be found in churches. Thus the common man derived what learning he had from looking at paintings. Thanks to painting, the Church instructed the people. This is why so many religious paintings were produced in the Middle Ages.

In a church, a painting was placed in the most important and sacred spot, above the altar before which the congregation knelt in prayer. The light filtering through the colourful stained glass windows was soft and rich, greatly enhancing the paintings and their gold leaf backgrounds. What a difference from the modern museum!

Who were these painters of the Middle Ages? They were certainly wonderful artists, but at the time a painter was not thought of as an artist. He was an artisan who went through a twelve-year apprenticeship to acquire the rules and techniques of his trade. Artists belonged to the same Guilds as doctors and pharmacists, and their studios resembled chemists' laboratories.
The art of painting was usually passed from father to son and a painter began his apprenticeship very young. The contract between master and

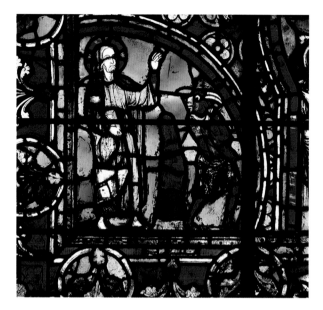

Anonymous ▶
The Temptation of Christ (*c.* 1200).
Stained glass, detail.
Chartres Cathedral.

Stained glass windows illuminated the churches but they also told a story from the Bible to the illiterate congregation. Stained glass was never signed.

Jean Malouel
(1370?-1415).
Pietà, called *La Grande Pietà ronde*
(*c.* 1400).
Oils on wood:
64,5 cm in diameter.

The unusual format of this painting was not chosen by the painter. It was specified by the purchaser, along with its size, colouring and subject.
▼

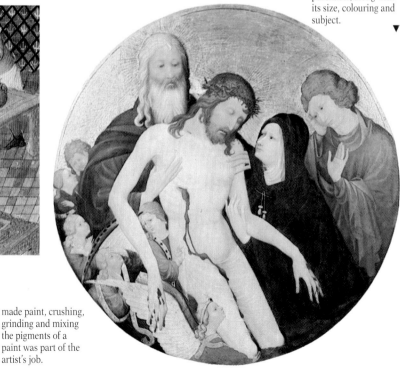

Anonymous ▲
The Woman painter Tamara.
Detail from a manuscript.
In the Middle Ages, when there was no such thing as ready-made paint, crushing, grinding and mixing the pigments of a paint was part of the artist's job.

pupil provided for the food and shelter of the apprentice and he was given an annual sum of money. During the period of apprenticeship, the master was to transmit all he knew to the pupil. In return, the young man cleaned the studio and his master's brushes, and mixed the paints. He copied drawings and painted the secondary areas of a work for, in those days, a painting was often the work of several people and was not signed.

A painter was in the service of the Church, or more rarely, of a king. A monk would commission a painting of a Biblical scene, usually a Madonna and Child or a Crucifixion. Everything was predetermined: the subject, the size, the colours, the price... It was out of the question for a painter to improvise or use his imagination. If the painting did not conform to the purchaser's specifications, he had the right to refuse it.

Medieval painting was quickly deemed clumsy and was forgotten in the 15th century, when the Renaissance brought fascinating new techniques into being.

In the 19th century, the painters of the Middle Ages were disparagingly dubbed "primitive painters". This name remains today, but it now stands for the fresh purity of their colours and the sensibility of the artists of the period.

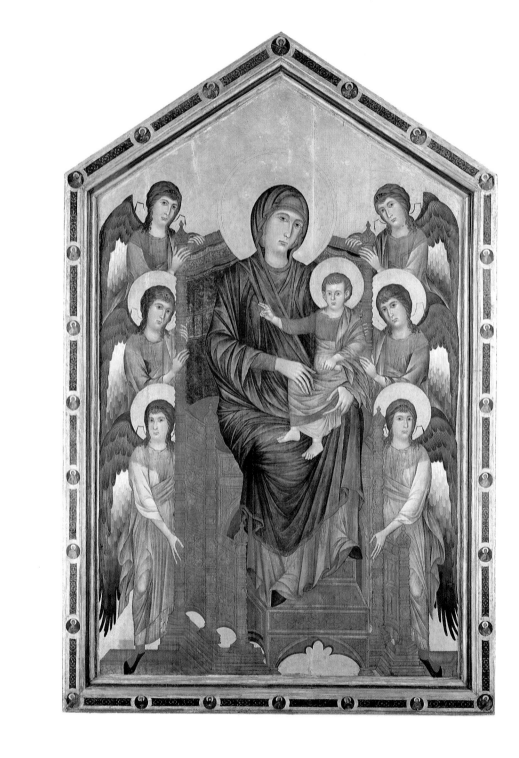

CIMABUE
painter of the unreal

<u>Like all the painters of the Middle Ages, Cimabue painted scenes from the Bible on commission. His paintings seem unrealistic, because everything in them is static and suspended over a void. But what if the artist was using this immobility to lead us into another world?</u>

Towards the end of the 13th century, this Florentine master, Cimabue, was commissioned to paint a *Madonna and Child* for the Church of San Francesco in Pisa.

a floating world

Cimabue set to work. In the middle of the painting he portrayed the Virgin Mary seated on a throne. She has a tender, slightly sad expression. It was unusual for a face to be given so much expression in the 13th century. Her son Jesus is on her lap. He faces us, and blesses the world with his right hand. Of all the figures, he is the only one to have been given ears: this is because he is the only one who is "listening" to the world.

On either side of the Madonna, six angels fill all the available space with their wings. How uncomfortable they appear, squeezed between the throne and the picture-frame! They look as though they could not move or spread their wings. Their clothes are heavy and stiff as if they had been made of wood or stone.

And yet, despite all this weight, the angels are floating. The lower two angels are standing on the edges of the throne, but the other four are suspended in space. No ground, no clouds: was this a mistake on Cimabue's part? Certainly not! It was simply a way of representing a different world to ours: God's universe.

◀ **Cenni di Pepe**, called **Cimabue**, Italian painter (1240?-1302). *Maestà; the Madonna and Child in Majesty surrounded by angels* (c. 1300?). Wood panel: height: 4,27 metres, width: 3,80 metres. Purchased by the Louvre in 1811, under Napoleon.

In Majesty
This is what the Madonna or Virgin is called when she is seated on a throne in a formal pose. She always faces forward, as stiff and dignified as a lady of rank. Christ and the Trinity were also painted "in Majesty".

19

how did Cimabue compose his painting?

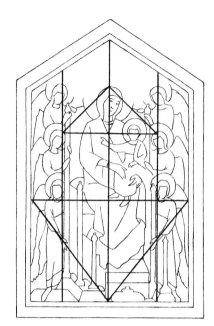

Composition
The bold lines on this diagram show the lines drawn by Cimabue before he drew his cartoon, or preliminary design. They were of course then completely covered over with ◀ paint.

What is symmetry?
Three angels on one side, and three angels on the other: all their hands are in the same position, the folds in their garments are the same, as is the expression on their faces. This is perfect symmetry, as if the painter had put a tall mirror in place of the Madonna. The axis of the painting is vertical and exactly in the middle.

Blue

Yellow

Red

▲
Primary colours

By mixing equal quantities of two primary colours one produces a secondary colour.

Secondary colours
▼

Yellow + Blue = Green

Red + Yellow = Orange

Blue + Red = Violet

Like all painters, Cimabue composed his painting by drawing composition lines that define the basic structure of the painting. Each line is intended to capture one's attention. The eye is always attracted to the apex of a triangle, so that is where the artist places the most important component of his work.
Religious painters regularly used these triangles, because they symbolized calm and balance and were reminiscent of the ribbed vaults of Gothic cathedrals.

making the colours shine

What a lot of bright colours there are in this painting! Red for the cushion, for the wings of the angels in the middle, and for the Madonna's sleeves; blue for her robe and for the wings of the remaining angels. Blue is the dominant colour, but it is the red that stands out. This is because it is a "warm" colour. Note that Cimabue did not use a single blue or red, he employed a whole range of them.

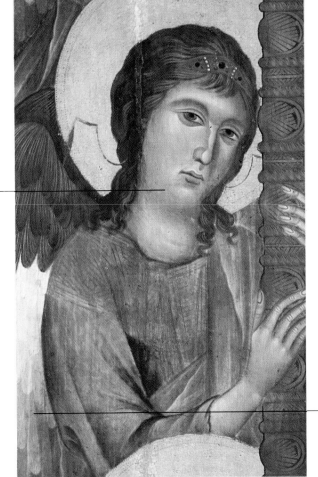

Madonna and Child ▶
in Majesty
detail, an angel.

What is verdaccio?
Verdaccio is a mixture of burnt sienna, ochre, charcoal, chalk and raw umber, which has a greenish tinge. It was used to paint faces of people who were not real such as the Madonna, Christ, saints, and angels.

What was known about perspective?
In his painting, Cimabue used colour to create the illusion of volume. The laws of perspective that produce depth in a composition were unknown in the Middle Ages. They were discovered in the 14th century, and were systematically used by the 15th century.

The degrees of a colour
The angels' wings move imperceptibly from dark blue and red to very light blue and palest pink. This is called colour grading.

the colours provide the volume

Complementary colours
The theory of complementary colours in painting is that the effect of a primary colour will be heightened when it is placed next to the two others united into their secondary colour. Green is the complementary of red, violet of yellow and orange of blue.

How does one make a nose stand out from a face? How does one give volume to a fold? In the Middle Ages the laws of perspective were unknown, so they used colour. The greenish colour used to model the faces is a good example.

The colour is called "verdaccio". Cimabue added a touch of pink, a warm colour, to the "cold" verdaccio, thus giving an illusion of volume to the cheeks. He was one of the first to discover that a warm colour will seem to advance into the foreground, and that a cold one will retreat into the background.

how did Cimabue suggest paradise?

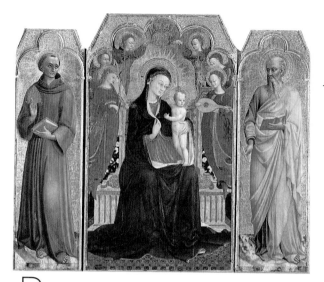

P aintings were never intended to be exhibited in museums. In the Middle Ages, they were most frequently hung in churches.

as big as a billboard!

The *Madonna and Child in Majesty* on its wood panel was placed behind and above the altar in the church of San Francesco in Pisa. A painting placed behind an altar was known as a "retable", and it had to be very large if the faithful were to be able to admire it from the other end of the church. This one is 4,27 metres high and 3,80 metres wide, which is immense. A work of this size could never pass through a door, even if it were folded in two. The painting is almost the size of a modern advertising billboard.

a technique from the East

Cimabue was also supposed to produce a work that would inspire Christians with respect and admiration, a work that would appeal to them and help them to pray. To do so, he had a truly gorgeous material at his disposal: gold.

What is a retable?
The word comes from the Catalan (Spanish dialect) *rea table* and means "at the rear of the table". A retable is a panel made of a hard wood that is painted or otherwise decorated. Retables were always placed in the most sacred spot of a church, behind the altar: the "table" on which the priest celebrates mass. Retables are composed of one, two or three panels.

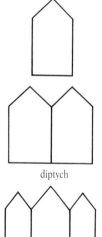

diptych

triptych

Different kinds ▲
of retables

Not just gold paint, but real gold!
The technique of applying gold-leaf was already very old. It had been developed by the Byzantines and the Greeks who used it to decorate their churches. The use of gold-leaf finally went out of fashion in the 15th century, when painters began to portray their subjects more realistically thanks to the discovery of perspective. They slowly abandoned gold-leaf because it made the backgrounds too flat.
Gold-leaf will catch the smallest gleam of light and brighten the overall painting.

How is gold-leaf applied?
Gold is a soft metal that can be flattened into very thin sheets. Before applying it to a surface, the areas to be gold-leafed are primed with a fine coat of a red clay called "red bole". Next, using a gold-knife, which is an awl with an animal tooth or hard precious stone in place of a blade, the gold-leaf is hammered and rubbed until it completely adheres
◄ to the surface.

gold-leaf gold-knife red bole

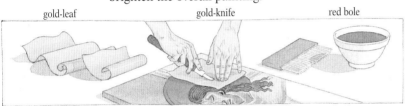

The gold background of the *Madonna and Child in Majesty* appears to be uniform, but a closer look reveals the elaborate treatment it was given. Cimabue pricked out a fine tracery of flowers in filigree to form the haloes of his subjects, and outlined them with a circle of closely-spaced dots.

a solid gold paradise

Of course, gold is a symbol of riches. To cover a religious painting in gold-leaf, therefore, was to offer God one's most beautiful and valuable possession.Gold also served to show the faithful that God's realm is magnificent and to make them wish to join him there.
This mass of gold suggests a luminous, rich and wonderful paradise. Nowadays we might find this image a little depressing, for it no longer corresponds to our concept of paradise.

▲

Madonna and Child in Majesty
detail of the frame.

The frame was an integral part of the whole. Here Cimabue has painted and gilded it like the rest.
This medallion, at the apex of the frame, portrays Christ.
The other twenty-five medallions are portraits of saints and angels.

23

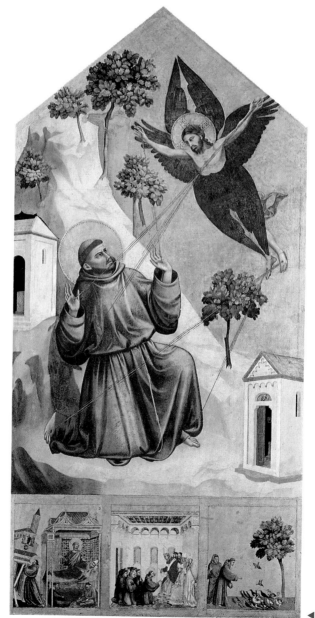

Francis is going to repair my house which, as you can see, is falling to pieces.

Jacques de Voragine, *The Golden Legend* (a history of the saints).

Giotto, Italian painter (1266/67?-1337). *St Francis of Assisi receiving the Stigmata* (c. 1300). Wood panel : height: 3,13 metres, width: 1,63 metres. Purchased by the Louvre in 1814.

Lower part, or predella: Left: *The dream of Pope Innocent III.* Centre: *The Pope authorizes St Francis to found the Franciscan order.* Right: *St Francis preaching to the birds.*

GIOTTO

painter of the real

<u>Legend has it that one day the young painter Cimabue saw a shepherd boy, Giotto di Bondone, drawing a sheep on a rock. Amazed by the talent of the boy, Cimabue took him on as an apprentice. Very soon Giotto surpassed his master and became one of the most important painters in Europe.</u>

Around 1300, Giotto joined his one-time teacher in Pisa, where Cimabue was painting his *Madonna and Child in Majesty*. For his part, Giotto had been commissioned a life of St Francis of Assisi.

What a change had taken place since they had last worked together! A hill, some trees, a couple of houses: Nature, albeit very simplified, had made its entrance into painting. A man kneeling on the ground, here is real life in a painting! For that man wearing a habit, with tonsured hair and a halo, is St Francis, a monk who actually existed.

Who was St Francis of Assisi?
He was a rich merchant of the 13th century who at the age of 25 abandoned his fortune for God, and founded a religious order of mendicant monks: the Franciscan order. They were known as "God's poor".

the picture of a miracle

St Francis' face is raised towards a bird-man also having a halo: Jesus Christ. Straight lines join the palms of their hands, their feet and their hearts.
Why the lines? Because Giotto was painting a miracle. He chose to depict the moment when Christ gave St Francis the "Stigmata", which are the wounds Christ received on the cross, and those rays symbolize the mystic tie that united them at that moment.

25

St Francis of Assisi receiving the Stigmata, ◀ detail.

how did Giotto paint reality?

How could one describe Giotto's St Francis: does he look like an exceptional person come from another world, or does he resemble an ordinary man whose life was an extraordinary adventure?

small touches of realism

When painting the Madonna and the angels, Cimabue made them float in the air. To better depict paradise, he used his imagination to create an unreal world.

Giotto, on the other hand, wanted his painting to seem real. His St Francis is like any other man, and he really seems made of flesh and bone.

He is kneeling on the ground in prayer, and his habit hangs in natural folds around his body, though they are occasionally a little stiff, round his arms, for example. Even his face differs from faces painted up to then: Giotto gave St Francis the tones of a real face. He also gave him... ears! Not as a symbol of "listening" to the world, but because men do have ears.

Giotto lingered over the face of his St Francis, giving it expression. The frown and creases in his brow help to give the saint a surprised, or even apprehensive, look as the miracle takes place. One could almost think that Giotto painted St Francis using a model, he is so life-like.

Anecdote about an insect
One day Giotto drew a fly on the nose of a figure Cimabue was painting. It was so realistic that Cimabue tried to brush it off several times before he realized what it was!

26

Modelling
Painting a tangerine is
not simply a matter of
painting an orange
circle. For it to look
real it has to be given
its rounded shape. To
achieve this one has to
grade the colours,
using a bright orange
for the area of the
tangerine that catches
the light, and a darker,
duller orange for the
parts that are in
shadow, passing
through as many
colour graduations
as are necessary to go
smoothly from light
to dark.

he carved in light

To make it even more life-like, to give the faces
even more relief, Giotto did not bathe the painting
in a uniform light.
Instead, he placed a strong light on the bridge of
St Francis' nose, and on his cheeks and forehead, plun-
ging his eyelids, the lower part of his cheeks and the
back of his head into shadow. Where is the source of
this light, the "sunlight" in the painting?
It is on the upper right hand side: the light comes from
Christ himself.

at the dawn
of the Renaissance

Giotto began his search for realism very early. He liked
to watch how people behaved, to study animals and
observe the world around him. Vasari, one of the
major art historians of the 16th century wrote that
"Giotto was the pupil of Nature, and not the pupil of
Man".
Admittedly, Giotto was still far from a true realism:
he crowded two people, two whole churches as well as
an entire mountain into a single painting! In the 14th
century the techniques of composition were still ill-
understood.
Giotto was, however, already far in advance of the tea-
ching he had received from Cimabue. He retained the
gold-leaf background that was traditionally used in
religious painting to symbolize paradise, but he used it
to form the sky. Everything he did had the effect of
bringing this religious scene down to earth, and of
giving religion a solid image.
In attempting to paint an ordinary human being, by
placing him in a setting that represented reality —
however awkwardly — Giotto was the precursor in a
new way of thinking, that of the Renaissance.

St Francis of Assisi ▲
receiving the Stigmata,
detail.

Christ appears to St
Francis as a Seraph,
an angel who is
superior to all the
others and who was
always shown with six
wings.

**What is the
Renaissance?**
Renaissance, which
is literally "re-birth",
means both "return"
and "renewal". After
the Middle Ages,
during which art made
little progress, the
artists of the 15th and
16th centuries
rediscovered
Antiquity. Inspired
by the Greeks and the
Romans, they began to
paint the human body,
as well as making
parallel discoveries
about new techniques
like perspective and
modelling.

27

what was Giotto's technique?

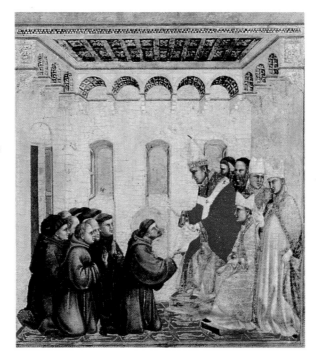

◀ *St Francis of Assisi receiving the Stigmata*, detail of the predella.

Pope Innocent III, wearing red, authorizes St Francis to found his own religious order, embracing poverty. What a contrast between the rich vestments worn by the Pope and the habits of the monks!

Painting on wood is a delicate matter. So the painter took great care in selecting the pieces he would use. The planks had to be hard (preferably of oak, poplar, willow or lime) and perfectly dry in order not to warp.

painter and carpenter

How is charcoal used?
Charcoal is generally used to make rough sketches before a painting is begun. If the painter makes a mistake, he merely has to "rub out" the charcoal line by dusting it with a brush.

Once he had selected the wood, he proceeded to remove imperfections such as knots and fill the holes with a mixture of wood shavings and glue.
Next he spread over it several coats of glue made from boiled clippings of hide. Sometimes he added a layer of fine linen canvas, also impregnated with glue.
Once that ground was dry, he added two coats of a preparation of glue mixed with gypsum, chalk or plaster. When that dried, the panel was finally ready for painting.
The painter might begin by sketching out his subject in charcoal and then tracing over it with diluted ink.

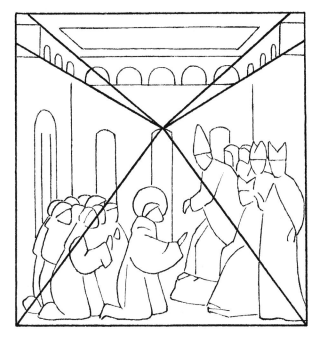

This is an optical illusion, a "trick" to make one think that a painting has depth. One draws lines from the foreground to the background of the painting, until they meet at a "vanishing point" on the "horizon line". The "line" along which a building will stand and the lines governing its height must both "vanish" at the same point for it to be "in perspective". Giotto was one of the first painters to use perspective.

Fra Angelico
(1400?-1455).
The Coronation of the Virgin (1430/35). Tempera on wood: 209 x 206 cm. The predella: *Five scenes from the life of St Dominic.*
▼

When this was done, he proceeded to apply the red bole onto which he stamped the gold-leaf. Only then did he actually start painting, beginning with the background and ending with the figures and faces.
But before a painting could even be begun, the pigments had to be prepared by the apprentice. He first selected the stone, earth or dried plant of the desired colour. Using a mortar and pestle he reduced it to a powder. He then "bound" the powder with glue, or, for "tempera" painting, he left the pigment as a powder until the very last minute, when it was mixed with egg or fig juice.

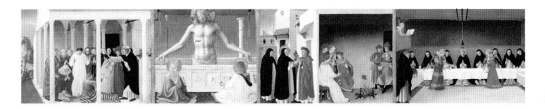

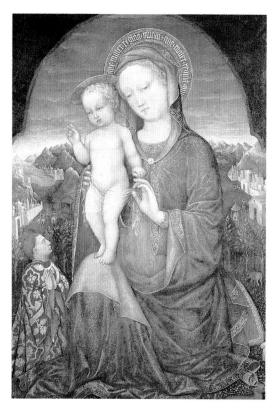

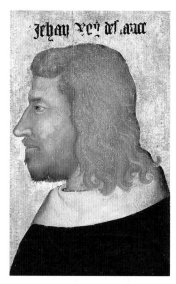

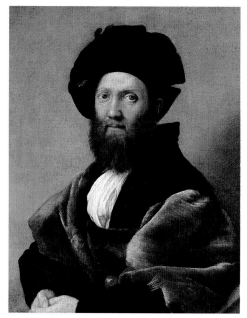

Jacopo Bellini ▲
(active 1423 to 1470).
*The Madonna and
Child adored by
Lionello d'Este*
(*c.* 1450).
Oils on wood:
60 x 40 cm.

The purchaser can be
seen at the bottom left
of his painting. This
was the only way for
someone to have his
portrait done, before
"portraiture" really
existed.

School of Paris ▲
*Jean II le Bon, King of
France* (*c.* 1350).
Oils on wood:
59,8 x 44,6 cm.

The first portrait to
appear outside a
religious painting.

Raffaello Sanzio,
called **Raphael**
(1483-1520).
Balthasare Castiglione
(*c.* 1514/15).
Oils on canvas:
82 x 67 cm.

This man's very blue
gaze seems to create
a magic link between
him and the spectator. ▶

The portrait

Nowadays famous faces are widely reproduced in the media. Television, magazines and newspapers spread them throughout the world.
But prior to the invention of photography, things were not so easy. How could a king become known to all his subjects? There was only one way: to commission a portrait from a painter, sculptor or engraver.

In Medieval times, artists painted very few portraits, because religion was the main interest. Portraiture began to flourish at the end of the Middle Ages, when the individual began to gain in importance.
The first portraits, dating from the 14th century, were still part of religious painting. When a living person was portrayed, he was generally shown on his knees next to a Crucifixion or a Madonna and Child. He was frequently shown much smaller than the religious figures in the painting, for, even if he was a king or a prince, he could not be painted the same size as God.

What a shock the first portrait of a man alone must have produced! This historic and totally revolutionary painting was painted by an unknown artist and it is the portrait of a king of France, Jean le Bon (1319-1364).

Over the centuries that followed, every king, prince and governor was to have himself "portraited". At first they were invariably shown in profile, as they were on coins and medallions, because painting techniques were not advanced enough to produce a proper likeness in full-face. After the discoveries that were made about colour and modelling, they began to be shown in three-quarter profiles and at last, in full-face. Then they began to be painted half-length, in a flattering pose and richly apparelled. That is when the "display portrait" came into being.

31

Frans Hals ▶
(1581/85?-1666).
The Gipsy girl
(*c.* 1628/30).
Oils on wood:
58 x 52 cm.
In the 17th century,
painters began to
portray the common
people, for the sheer
pleasure of painting.

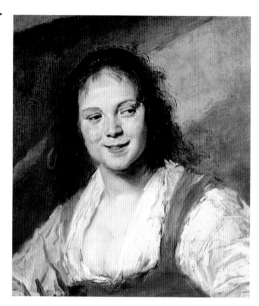

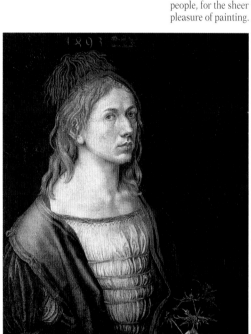

▲
Albrecht Dürer
(1471-1528).
Self-portrait (1493).
Parchment mounted
on canvas :
56 x 44 cm.

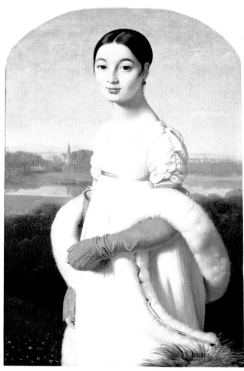

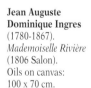

**Jean Auguste
Dominique Ingres**
(1780-1867).
Mademoiselle Rivière
(1806 Salon).
Oils on canvas:
100 x 70 cm.

Ingres often distorted
his images. He was
more interested in
purity of line, and
created a new taste
in beauty. ▶

By then one no longer needed to be a king or a queen to have one's portrait done, but one still had to be rich!

Artists made a good living out of painting the portraits of the well-off, but they also painted them for pleasure. They experimented with their own faces, and thus the "self portrait" came into fashion. From the 17th century, they painted complete unknowns, often unusual-looking people full of malice or fun.

The portrait continued to gain in popularity, and "group portraits" were done of the members of a same firm, profession, or social group. These paintings were less costly, since the fee was divided by the number of people in the painting.

When someone in a powerful position commissioned a group portrait, he usually intended it as publicity for himself. Thus Napoleon commissioned the painter David to paint his coronation as Emperor in 1806 so that the entire nation could share in the historic event. 150 years later, television would doubtless achieve the same result.

From 1830, the art of portraiture went into a fast decline. A new technique was available to all levels of society: photography. Who could prefer the days spent sitting for a portrait to the instant gratification provided by a camera?

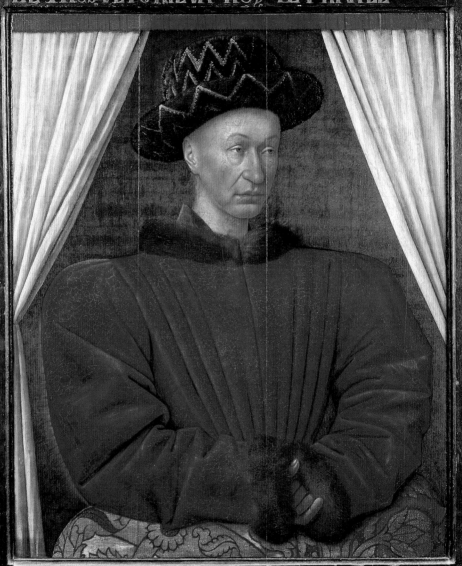

LE TRESVICTORIEVX ROY'DE FRANCE

CHARLES · SEPTIESME · DE CE NOM

JEAN FOUQUET

painter of kings

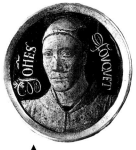

He looks kind, but has an aura of power. He looks modest, but his pose is full of majesty. He is not handsome, but he inspires respect. This is Charles, seventh of that name, very victorious king of France.

Nearly a metre in height is very big for a portrait. Fouquet painted his king half-length and almost life-sized. He posed him at a slightly three-quarters angle and not in profile as painters of the previous century used to do. This painting is typical of the official portrait of the 16th century.

What is the setting in which Charles VII is posed? It is difficult to say, he has been painted in "close-up", and he covers practically the whole surface of the painting. He could be sitting in the royal box in the *Sainte Chapelle* at Bourges, the city in which he lived before ascending the throne, for his hands rest on a brocade cushion, as if he were at prayer.

is this man really a king?

Charles VII wears no crown or royal arms, but the inscription on the frame leaves no room for doubt, he is definitely "the very victorious King of France, Charles, Seventh of that name". By writing his king's name on the frame, Jean Fouquet produced his first official portrait. A promising beginning, for several years later he became the official court painter. He was to be in charge of all artistic activity during the reign of Louis XI, Charles VII's son.

Jean Fouquet,
French painter (1420?-1480?).
Charles VII, King of France (c. 1445).
Wood panel: height: 0,86 metres, width: 0,71 metres.
When it was acquired by the Louvre in 1838, it was ascribed to an "unknown Greek ◀ painter".

Who was Charles VII?
On the death of his father Charles VI in 1422, Charles VII was proclaimed king in the Midi and the South-West of France. He won back the rest of his kingdom from the English with the help of Joan of Arc, who had him crowned king of all France at Reims in 1429. Charles VII died in 1461 and is buried in the basilica of Saint-Denis, on the outskirts of Paris.

35

what makes Fouquet's painting royal?

Nothing openly denotes that this painting is a royal portrait, and yet everything about it implies that it is. Its very formal composition, for example, gives Charles VII a definite air of majesty.

The components of the painting are laid out geometrically. The shoulders and the arms form a rectangle, the folds in his doublet form an inverted triangle, the folds of the curtains echo the folds in his doublet and form another triangle, pointing upwards.

This combination of triangles frames the figure in a lozenge, which accentuates the impressive breadth of his shoulders.

▲ *Charles VII, King of France*, detail.

Some historians believe that this inscription is contemporary and commemorates the king's many victories over the English, who occupied part of France at the time. Others believe that it was added after the king's death.

Did Fouquet select his colours at random?
His choice of colours indicates that the figure is a king. White symbolizes purity, and was used for the fleurs de lys on the royal coat of arms. Red symbolizes charity, and is the blood of Christ. Green signifies the hope of a better life and blue is the colour of French royalty.

a theatrical presentation

Fouquet separated the king from the common mortal with a white curtain. This clever stratagem makes Charles VII appear to be on a stage, and though he is painted in close-up, he remains distant and unapproachable. The bright lighting brings out the splendour of the velvets, furs, brocade, and gold braid. Fouquet was

◀ *La Belle Agnès* (before 1450). Pencil drawing after Fouquet of Agnès Sorel, king Charles VII's favourite.

At the time an official painter was very useful to a king, for he was the only person who could make his face known to the people. Official painters were also entrusted with painting the portraits

of marriageable princesses. When the German painter Holbein painted the portrait of Anne of Cleves for king Henry VIII of England, the king fell in love with her. What a disappointment for him when he finally saw her in the flesh! Holbein had painted her full-face, thereby disguising her outsize nose.

already greatly admired in his day for his talent for reproducing the richness of different materials.

That essential part of a painting, light, almost always comes from the left. Why?

If one puts oneself in the place of a painter, one realizes that the light cannot come from the front, because it would be behind the model, nor from the right, because the painter's arm would cast a shadow. It can only come from the left, unless the painter is left-handed, of course.

Did Fouquet have lasting fame?

During his lifetime, Fouquet was considered to be among the greatest painters of his day. He was forgotten in the 16th century and remained so for about 300 years. It was not until the 19th century that he was rediscovered and established as France's greatest portrait painter.

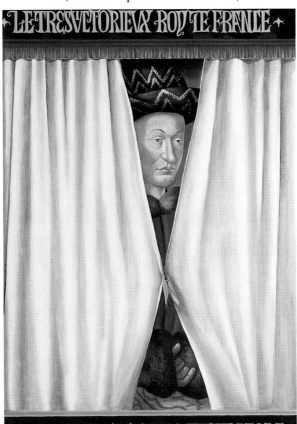

Lucien Mathelin
Parody of the painting by Jean Fouquet
(1973).
Oils on canvas:
81 x 65 cm.

By drawing the curtains, the painter has made the king into a spectator instead of an actor. Charles VII now looks as if he is spying on us!

◀ 37

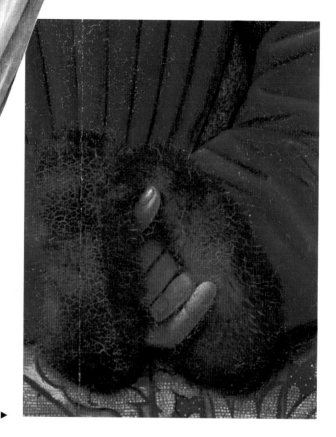

*Charles VII, King
of France*, detail.

Flesh, velvet, fur,
brocade. Fouquet
treated each surface
differently. ▶

W hat a contrast between the mat white of the curtain and the slightly coppery beige of the king's face! The secret behind this contrast is Fouquet's use of oil paints.
For the curtain he used the classic tempera, mixing the pigments with egg. But for the face he used oil paints.

advantages of oil over egg

Oil was not unknown as a medium in painting, having been employed for a long time to make the varnish used to finish tempera. The painter Cennini had already suggested in the 16th century that oil be left to reduce in the sun to rid it of impurities.

Who invented oil painting?
The Flemish painters were the first to use oil paints. For many years the invention was attributed to Jan Van Eyck (1390/1400?-1441). Flemish painters painted in great detail, and only oil paint, permitted them to alter their work.

The innovation was to use oil to bind the pigments. It had a number of advantages: it made the colours bright and transparent and kept the paint soft right to the tip of the brush. Above all it stopped the paint from drying too quickly. Thus the painter could alter his work with "pentimentos", because it takes oil paint a year to dry completely!

From the 15th century oil paints took over from other materials and each painter developed his own technique. The Dutch painters painted in very thin layers to achieve a unified surface. The Italians, and above all the Venetians, applied layers of glaze to obtain luminous, eye-catching effects.

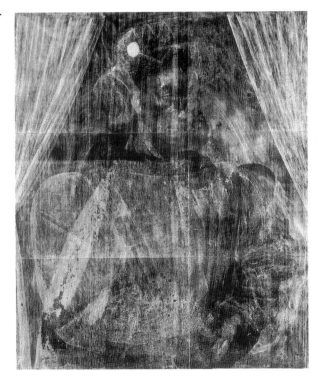

X-ray of Fouquet's ▶ painting taken by the research laboratory of the French museums.

When this painting was X-rayed, a curious discovery was made. Underneath the royal portrait there was a *Madonna and Child* that Fouquet had never completed! This *Madonna* is identical to the one now in the Musée des Beaux-Arts in Antwerp, Belgium.

Can wood supports warp?
Fouquet's support is composed of three oak planks set in a grooved frame. The planks have separated over the years because wood is a living material that shrinks with heat and swells with damp. To avoid this from happening, museums are kept at an even temperature and humidity all the year round.

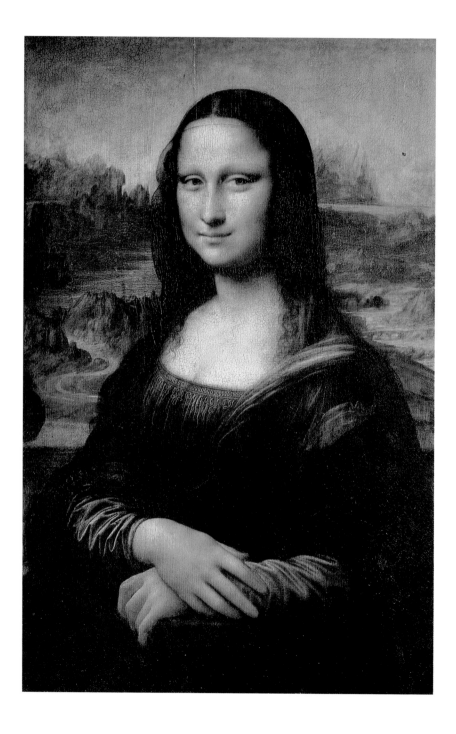

DA VINCI
painter of the divine

Who has never seen this lady? She is the *Mona Lisa*, the jewel in the Louvre's collection. She is so valuable that she has to be protected with bullet-proof glass! Each day thousands of visitors, perplexed and admiring, wonder why she is so popular. What is so special about *'La Gioconda'*?

La Gioconda has always been popular. She was considered a masterpiece as far back as 1550, some fifty years after she was painted. How ever did she become such a world-wide celebrity? To understand this phenomenon, one has to look at her with a fresh eye, and forget everything one knows about her.

a model of good manners

Leonardo da Vinci painted a half-length, three-quarter angled portrait of a young woman. She is probably seated, because her left arm is resting on the arm of a chair. Leonardo has given her the model pose for a young woman of good family. Indeed, a manual of manners written in the 16th century stated that the correct way of sitting was with one's right hand placed over one's left at waist height!

Behind her there is a landscape. She is almost certainly seated on a covered balcony, a loggia, overlooking the countryside. In fact, Leonardo originally painted a column on each side, but the painting was cut down by a few centimetres in the 16th century and the columns were lost.

Who is the Mona Lisa?
In Italian, *gioconda* means "joyful". Who is this "joyful girl" who sat for Leonardo? Is she, as is often maintained, Mona Lisa, the wife of the Florentine banker Francesco del Giocondo? Or is she Isabella d'Este, or else the Duchess of Francavilla? Nobody knows. Some people even go so far as to say that she is... Leonardo da Vinci himself!

Leonardo da Vinci,
Italian painter
(1452-1519).
'La Gioconda', called
Mona Lisa (1503/1506).
Wood panel:
height: 0,77 metres,
width: 0,53 metres.
Collection of king
François I of France.
Hung in the Louvre
◄ from 1804.

how did Leonardo achieve such sweetness?

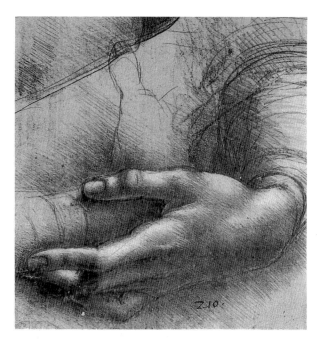

A lot has been said about the *Mona Lisa*'s famous smile. And yet she had every excuse to look tired. To sit still for hours while posing is often exhausting. At the end of the first hour one is likely to become as stiff and cold as marble. Sitting still for long stretches at a time makes the mind wander and the body go rigid.

Mona Lisa mustn't be bored...

X-ray of *Mona Lisa*
The X-rays disclosed fingerprints that only the experts could identify. They belong to Leonardo himself! He used to soften the contours by stumping them with his thumb, giving them a hazy effect.

No wandering of the mind or stiffening of the body for 'La Gioconda'! Leonardo only made her sit for the preliminary sketches and hired clowns and musicians to amuse her. As a result, his model's body and gaze are very much alive. She gazes with amusement straight into our eyes.

No other painter has come so close to the real. One could almost believe that she is breathing. Leonardo da Vinci's mastery of technique dazzled his contemporaries. "One gets the impression", one of them said, "of something divine rather than human".

Sfumato
Sfumato means "smokey" in Italian. Leonardo used this technique systematically for faces, which gives them all a slight family air.

Even if one uses a magnifying glass, one cannot see a single brush-stroke, not a line, not a contour. This is because Leonardo also used... his fingers. He stumped the contours so that the passage from shadow to light, the "chiaroscuro", should be as subtle as possible. Everything seems to melt as if it were in a cloud of smoke. This technique is called *"sfumato"*.

in the laboratory of the chemist Leonardo da Vinci

Few of the secrets of Leonardo's technique are known. He painted in thin, more or less transparent layers and modelled the faces with highly diluted paint, in "washes" of brown tones. As a general rule his "palette" was limited, in other words, he used a narrow range of colours.

Leonardo loved experiments. He used paint bound with an extra quantity of oil, and greatly diluted it when he painted. Occasionally, he would overdo this, with the result that his paintings wrinkled as they dried. Luckily, *Mona Lisa* is in perfect condition.

Leonardo da Vinci
The Virgin and Child with St Anne, *The Madonna of the Rocks* and *St John the Baptist*, details. ▼

Grey squirrel
for painting details, Leonardo used a very fine brush made from the fur of the grey squirrel.

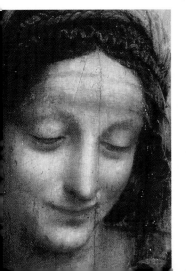
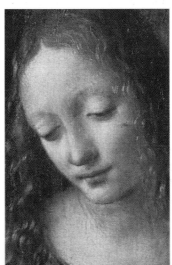

what is the landscape behind the Mona Lisa?

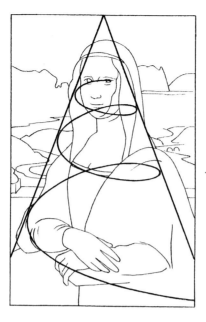

◀The composition
At first glance the composition of the painting appears simple. The young woman is positioned inside a triangle, a shape that denotes calm and equilibrium. But inside that, the lines of the composition go into a spiral. The whole upper part of her body, beginning with her hips, pivots towards the spectator. Her head emphasizes this movement and her eyes prolong it. This is how Leonardo has given movement to this apparently static painting.

Once a painter has placed the figure, what might he put behind it? A neutral background that will make the subject stand out, or a landscape that might draw attention away from it? For *Mona Lisa* Leonardo chose to paint a landscape. This was because for Leonardo the landscape was not just a setting, it was as essential a part of the painting as *Mona Lisa*'s smile.

a dream landscape

What was the landscape he chose to paint? A bit of the Italian countryside in which he lived? Not at all. In fact Leonardo painted not just one landscape, but several. The landscape at the bottom of the painting is a real one, painted in a range of earth colours. A path meanders to the left, a bridge crosses a river to the right. These are the only traces of man.

The path and the bridge lead up the painting to an ethereal world of dawn blue, a dream world. This almost inaccessible place is symbolic, it denotes the limits of the world in which 16th century man lived. And it is precisely at this place that the eyes of the *Mona Lisa* are situated.

If a painter wishes to see beauty that will arouse his love, he has inside himself the capacity to create this beauty. . . . And if, standing at the bottom of a valley, he wishes to see mountains, or high mountains, deep valleys or cliffs — which are the essence of the world both real and imagined— he has it all in his mind to begin with, and then in his hands.

44 Leonardo da Vinci

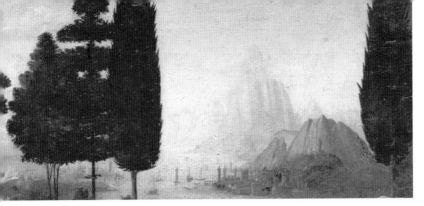

▲
Leonardo da Vinci
Annunciation
(1472/75), detail.
Oils on canvas:
98 x 217 cm.

If one analyzes the linear perspective in this painting, one immediately notices that there is more than one vanishing point. This is because Leonardo painted the landscape from several different angles. Intentionally, of course!

violet mountains

Leonardo greatly developed perspective. He was one of the first to realize that it obeys several laws. He discovered that distance does not just alter the apparent size of an object, it also softens its outline and distorts its colour. Here the distant components of the landscape fade into in a bluish mist. The shapes of the mountain and the river are blurred. Leonardo called these phenomena "colour perspective" and "fading perspective", but in fact these two perspectives blend into one, called "aerial perspective". Yet another of Leonardo da Vinci's discoveries.

The contours of an object are the least important part of the object... Therefore, O painter, draw not a line around your figures.

Leonardo da Vinci

Leonardo da Vinci ▶
Sketch of a landscape
(1473).
Pen and ink.

Many of Leonardo's drawings have inscriptions written back to front.

Neither Madonna nor princess, *'La Gioconda'* is above all a woman. A beautiful woman, for her face, without eyebrows or lashes, corresponds to the ideal of beauty of the period. But above all she is a woman of flesh and blood.

Leonardo da Vinci was also a philosopher

One should remember that Leonardo lived in the age of Humanism and the Renaissance. Divine harmony, the perfection of nature, an accord between the temporal and the eternal, these are the key concepts of the Renaissance. The individual now held a prominent place in the scheme of things, and had to master his own life and pierce the secrets of nature.

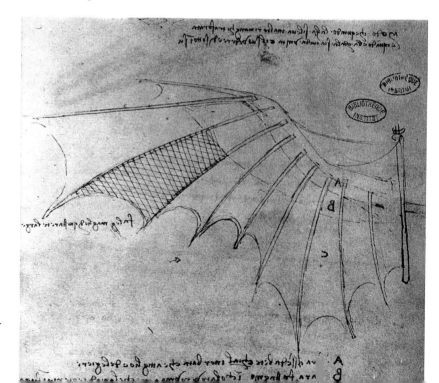

Leonardo da Vinci
Wing of a flying machine
(c. 1488).
Pen and ink:
23 x 16,4 cm.

46

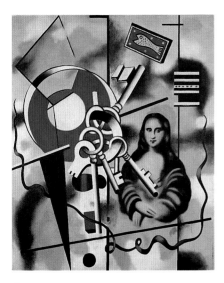

◀ **Henri Cadiou**
The Tear (1981).
Oils on canvas.

▲
Fernand Léger
The Mona Lisa with keys (1930).
Oils on canvas:
91 x 72 cm.

Leonardo felt he could help mankind in his quest, and he put his art at the service of knowledge. A true painter-philosopher, he believed himself to be a divine creator, a sort of link between nature and art.

he dissected corpses

In order to understand how things worked, he took up the study of science. He was very quickly fascinated by anatomy and spent hours engrossed in the dissection of corpses. Thanks to his research in optics, he made many discoveries about perspective and light. Botany, mathematics, engineering, everything was a source of enrichment to him.

The *Mona Lisa* is a complete summary of the philosophy of Leonardo and of the Renaissance man in general. By placing her eyes above the real landscape, thus making her look out over the earthly world, he was attempting to unite man and nature.

A classic work of the Renaissance, the *Mona Lisa* has continued to inspire artists... and forgers. Thousands of "parodies" of her, in paintings, sculptures and reproduced on everyday objects, have made the *Mona Lisa* into a household image.

La Gioconda **vanishes!**
On 22 August 1911, the *Mona Lisa* vanished from the Louvre. Two years of enquiry led to Florence, where Leonardo was born, and the home of a one-time Italian workman at the Louvre, Vincenzo Perruggia. Convinced that Napoleon had stolen all of the Italian paintings in the Louvre, he had decided to return them to Italy, beginning with the most beautiful of them all.

47

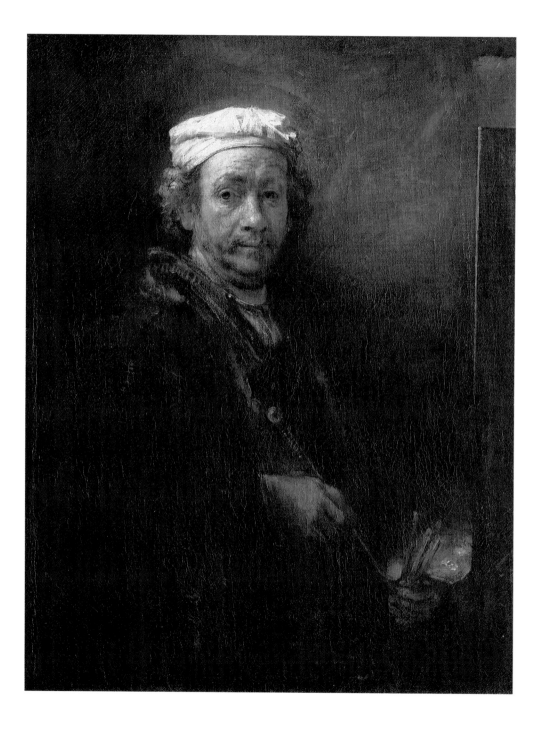

REMBRANDT
painter of the "soul"

Who is that man standing in the shadows with brushes in his hand? It is Rembrandt. He is the subject of the painting, but he is also the painter of it: Rembrandt painted by Rembrandt. This is just one of the many "self portraits" by the most famous of the Dutch artists.

In 1660, when Rembrandt began his *Portrait of the artist at his easel*, he was 54 years old. He had once been famous, but by 1660 his patrons were turning away from his work, for they no longer understood it. This was because Rembrandt didn't just stop at the appearance of his subjects. What he wanted to do was to "translate" reality, and not just reproduce it.

through the looking glass

In this self portrait Rembrandt painted himself in the darkness of his studio turning his head to face us, or rather, to face the mirror in which he saw himself reflected as he worked.
The light falls from above, to the left, lighting his cap, the right side of his face and the tops of his hands and his palette. Of the colours that are on the palette, only two warm patches, the vermilion and the yellow ochre, catch the light. The painting is composed as a pyramid of which Rembrandt's head is the apex.
Even knowing nothing about the painter's life, one can see that he is telling us how lonely he is. A deep beauty, composed of sweetness and gentleness, emanates from this work. Rembrandt was not interested in outward beauty, only in the beauty of the soul.

Harmenszoon van Rijn Rembrandt,
Dutch painter (1606-1669).
Portrait of the artist at his easel (1660).
Oils on canvas:
height: 1,11 metres,
width: 0,90 metres.
Purchased for the Louvre by Louis XIV in 1671.

The painter's tools
In his right hand Rembrandt is holding a "maulstick", a stick tipped with rags that a painter leant against his painting. It served to rest his hand while painting, and stop it from shaking.

49

what image of himself does Rembrandt project?

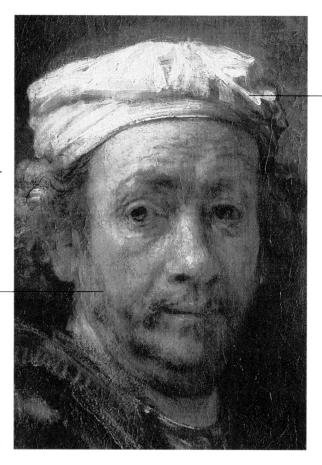

The glaze
To finish his paintings, Rembrandt covered them in a thin coat of transparent paint or lightly tinted varnish. This is called a "glaze". He used glazing to soften the contrasts and bring out the background.

Portrait of the artist at his easel, detail. ▶

The brushwork
In some places Rembrandt used so many layers of paint that he seemed to be sculpting rather than painting. On the cap, for example, the brush-strokes go in every direction. And yet, when one stands back from the painting, its contours appear natural.

The range of colours
Rembrandt's palette, that is to say, his choice of colours, is very narrow. They range from white (the cap) to black (the shadow behind his left hand), via ochre, vermilion and several tones of brown. One can perceive faintly some green and blue in the background, but the overall range is of warm colours.

A tired unshaven face, a double chin, gray hair, a coat that has undoubtedly seen better days, a plain cloth cap and a collarless shirt. Rembrandt disguised neither his age nor his poverty. He showed himself to be a penniless, aging man. But a good man, with a kindly, indulgent look.

a figure rising from the shadows

The lighting, extremely important to Rembrandt, seems to make his figure rise out of the shadows. Instead of painting on a white canvas and working in the

What is chiaroscuro?
The word is Italian and means "light-dark". Chiaroscuro is a technique that gives the illusion of relief. By alternating between light and shade, the painter models his objects and figures. Rembrandt was a master of this technique, though he was not the first to use it.

shadows as he went along, he began by covering it in a dark, earthy layer of paint. In this way, the light could only come from the subject himself. Thus Rembrandt created a new source of light. In this portrait, the light doesn't come in from the outside, but shines out from deep inside the painter. It was this style that made 17th century Dutch painting so famous.

Ten years earlier, the French painter Nicolas Poussin had also done a self portrait. but what a difference! His face is unsmiling, his stare is hard and cold. The bright light casts clear shadows. It comes straight in from the outside and lights the paintings in the background. By painting himself wearing a signet ring and sober, costly clothes, posing in front of his completed works, Poussin presented himself as an important person.

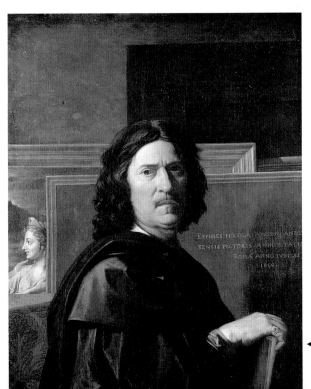

Why paint a self portrait?
Van Gogh wrote: "Rembrandt's self portraits are more than nature, they are revelations." It can be said that a self portrait is a face to face meeting with oneself. A painter who paints himself is attempting to discover and reveal his inner world.

Nicolas Poussin
Self- portrait (1650).
Oils on canvas:
◀ 98 x 74 cm.

51

did Rembrandt only paint portraits?

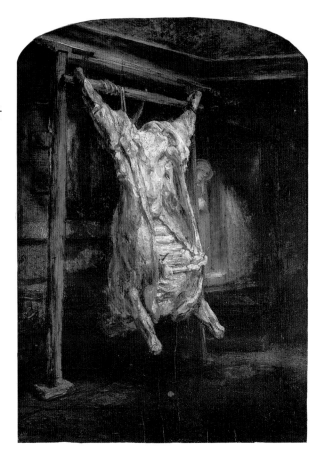

Rembrandt
The Flayed Ox (1655).
Oils on wood:
94 x 69 cm. ▶

The palette
The word has two meanings. It can be a round, oval or square piece of wood with a hole cut in it for the painter's thumb, on which he disposes and mixes his paints, or it can mean the range of colours used by a particular painter.

There was a terrible scandal when Rembrandt dared to paint a flayed ox. The Dutch burgomasters were shocked. They had been used to "noble" subjects such as religious scenes. How could Rembrandt, the master of portraiture, choose to paint something so vulgar?

down with convention!

Rembrandt had no time for rules and regulations. He had no intention of specializing in a single field, as his contemporaries did. He wanted to paint everything: portraits, self portraits, landscapes, genre scenes, reli-

The easel
A wooden support on three legs that holds a canvas upright or at the angle of the painter's choice during painting. The painting stood on a small shelf that could be raised or lowered according to the height at which the painter worked.

gious subjects, still lifes. The whole of Dutch 17th century painting represented by one man!

Of course, Rembrandt was not the only major painter in Holland. With painters like Frans Hals and Jan Vermeer, the 17th century was the "golden age" of Dutch painting. It was said that at the time there were 300 painters in Amsterdam and only 70 butchers!

Dutch artists rarely painted religious subjects, because the Seven Dutch Provinces, of which Holland was one, were Protestant, which is an austere religion. Protestants were also opposed to mythological painting because, they said, it gave the painter an excuse to paint nudes.

However, Rembrandt had no qualms about painting nude figures, even in religious scenes.

drawing-room paintings

It was fashionable to produce small paintings. Why? Because the market had changed. It was no longer just the aristocracy who bought paintings. The bourgeoisie, rich merchants who traded all over the world, had become all powerful. They wanted easel paintings that were not too large to decorate their homes. They commissioned portraits, of course, but they also purchased genre paintings, still lifes and landscapes, all of which were innovations at the time.

The canvas
By the 16th century, painters painted almost exclusively on canvas. They stretched and hammered a piece of tight-woven linen, cotton, or hemp onto a wood frame called a "stretcher". Canvas was an infinitely lighter support than a panel of wood. How convenient for large paintings...

Rembrandt
Self portraits painted at the age of 24 and 42. ▶

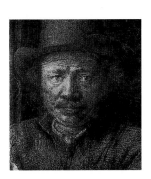

53

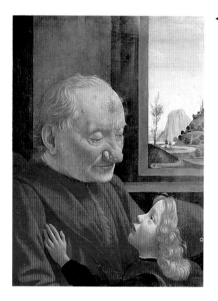

Domenico Ghirlandaio ◀
(1449-1494).
*Portrait of an old man
and a young boy*
(*c.* 1488).
Oils on wood:
63 x 46 cm.

Age and youth are joined
by the magic of a gaze.

Hieronymus Bosch ▶
(1450-1516).
The Ship of Fools
(*c.* 1500).
Oils on wood:
58 x 32 cm.

Gluttons and drunkards,
monks and buffoons set
sail in a "drunken
boat"...

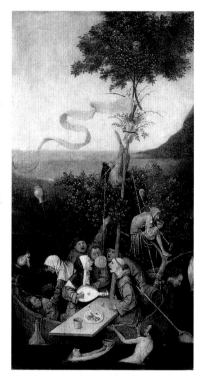

Michelangelo Merisi, ▶
called **Caravaggio**
(1570/71-1610).
The Fortune teller
(*c.* 1594/95).
Oils on canvas:
99 x 131 cm.

The fortune teller
seems to be reading
the young man's
fortune in his eyes,
rather than his hand...
or is she reading his
desires?

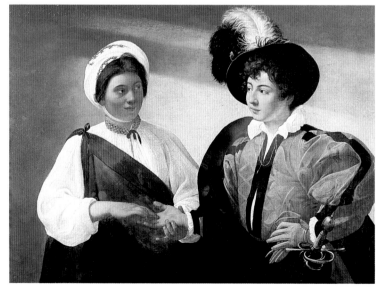

Genre painting

What is a "genre" painting? It is a painting that depicts scenes from everyday life. The French word "genre" means "kind", as in "mankind". Street scenes, peasants working in the fields, women at their washing, any subject would do as long as it was taken from real life.

The term genre did not come into use until the end of the 18th century, though this style of painting dates from the 17th. The painting of genre subjects was a reaction against the painting of the 16th century which was considered too mannered, sophisticated and "high-brow". The man who has come to symbolize this upheaval is an Italian painter, Michelangelo Merisi, called Caravaggio, after the town in Northern Italy where he was born.

Caravaggio took the subjects of his paintings from everywhere, ranging from everyday life to religion. What mattered was to paint them from life. He treated all of his subjects in the same style, painting a small number of figures, caught in full movement and presented in close-up. He would give these scenes a strong, dramatic light that accentuated the contrasts between light and shadow. His style of painting became extremely popular and was imitated all over Europe. It is called Tenebrism, from the Italian *tenebroso*, which means murky and refers to the dark shadows that characterize Caravaggio's work.

Beginning with Caravaggio, painters were to study people's natural, spontaneous behaviour. They began to depict ordinary people in a familiar world, something that had never previously been done in painting.

Painters' studios began to be filled with a steady stream of models of all types. The artist would dress them up in theatrical costumes according to

Bartolomé Esteban Murillo (1618-1682). *The Young beggar* (c. 1650). Oils on canvas: 134 x 110 cm.

This Spanish painter was a follower of Caravaggio. Here he depicts without sentimentality the dire poverty of a child in Seville. ▼

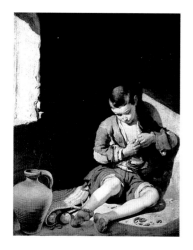

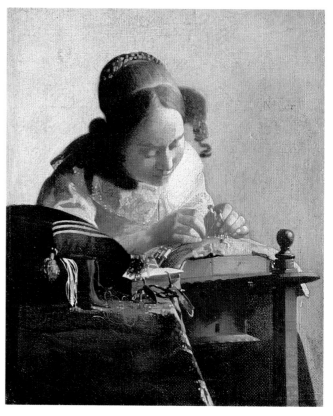

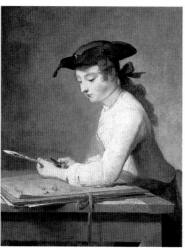

◄ **Jean Siméon Chardin** (1699-1779). *The Young draughtsman sharpening his pencil* (1737). Oils on canvas: 80 x 65 cm.

Here is another everyday scene. There is a definite relationship between these three genre paintings, despite the fact that they are from such different countries and periods.

▲ **Jan Vermeer** (1632-1675). *The Lacemaker* (c. 1665). Oils on wood: 24 x 21 cm.

Vermeer, master of pale blues and yellows, portrayed the modest simplicity of the woman's task in all its beauty.

the subject he wished to paint. Sometimes, if he wanted to paint the zest of life, he would portray his models drinking or playing musical instruments. Or else he chose the opposite, the misery of life, as the Spanish painter Murillo did with *The Young beggar*.

This new style of painting was immediately popular, especially since small paintings that were easy to handle had made their appearance. They are called "easel paintings". The rising Dutch bourgeoisie, for example, covered their walls with them. But critics and art specialists looked on them with disdain. To them, these were "minor" or "low" works.

Despite the opinion of the specialists, all the major painters were fascinated by genre subjects, and widened their scope to include paintings of the life of the bourgeoisie. The Dutch painter Vermeer or the French painters Watteau, Fragonard, Boucher and Chardin were the masters of genre painting in the 17th and 18th centuries.

On the eve of the French Revolution, painters began to abandon genre painting, because they felt the subjects were too light and frivolous. Virtue and noble sentiments came back into fashion. This frequently resulted in theatrical compositions that were too sentimental to be "true". Throughout the first half of the 19th century, genre painting was abandoned in favour of grander subjects, inspired by history or mythology.

It wasn't until the arrival of the Impressionists in the late 19th century that genre painting came back into its own.

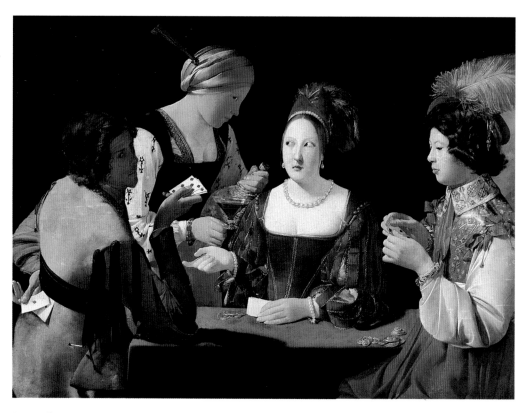

Georges de La Tour, ▲
French painter
(1593-1652).
*The Cheat holding the
ace of Diamonds*
(c. 1635).
Oils on canvas:
height: 1,06 metres,
width: 1,45 metres.
Signature on the
bottom left-hand side,
on the edge of the
table.
Purchased by the
Louvre in 1972.

The works of Georges
de La Tour, mainly
treating religious
subjects, can be
divided into two areas.
"Daytime" paintings in
which he used a cold,
clear daylight, and
"night-time" ones that
were lit by candlelight,
for which La Tour
limited his palette to

brown tones, and
reduced his volumes
to a few simple planes.
*The Cheat holding the
ace of Diamonds* ,
painted in about 1635,
is one of the last of his
"daytime" paintings.
 It is considered the
"key" painting in
George de La Tour's
work.

LA TOUR
painter of mysteries

<u>On the surface the subject is commonplace: three people sitting round a table, silently concentrating on their game of cards. However, the atmosphere is heavy and the faces are tense. What are the secret goings-on in this mysterious painting?</u>

The scene would make an excellent shot for a film. Georges de La Tour, the director, placed his four actors around three sides of a square table. The fourth side is empty. That is the audience's seat. Thus the spectator finds himself involved in the action.

What is the composition of the painting?
Once again, there is a triangle into which the three people on the left have been placed. The triangle is off-centre and the servant's head is its apex. The young man seated on the right is very much excluded from it.

a stifling atmosphere

The space is so narrow that everybody is squeezed up against his neighbour and hemmed in by the dark neutral background. The cold, dull light shining in from the left gives a feeling of unease. The painting is airless and stifling.

And yet Georges de La Tour took great care in placing his figures. Each person is on a different plane and in a distinctive pose. To the right sits a young man. The light is shining straight onto him, it is his turn to play. On the left, there is a man who has turned his back towards us, and whose face is profiled in the shadows. He looks as though he is making a secret signal to an accomplice. A strange-looking woman sits facing us. Her look and her finger are pointing to something. Behind her stands a servant turned three-quarters towards the spectator. To whom is she serving the glass of wine? The atmosphere is tense, the stage is narrow: what a feeling of suspense!

What is the card game they are playing?
They are playing a game called "lansquenet" that was played all over central Europe at the time, of which the trumps were the ace and the king. The ace of Diamonds also symbolizes the receiving of news or a letter.

59

how did Georges de La Tour put his actors in touch?

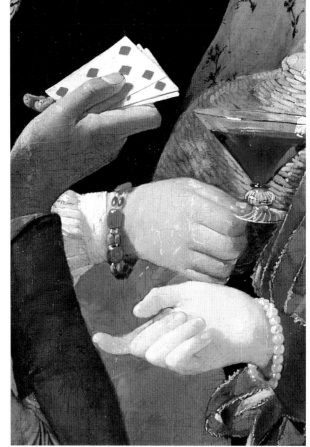

◀ *The Cheat holding the ace of Diamonds*, detail.

The man on the left whose face is in shadow is the first to attract the eye. His head is turned towards us but it is his hands that are most noticeable. With his left hand he is pulling an ace of Diamonds from his belt, which is going to make him win the game. As he shows us the cards he is holding in his right hand, his gesture directs the eye towards the two women the other side of the table: the servant girl and, above all, her mistress.

a silent language

What a strange face the woman has! It has been compared to an ostrich's egg because of its milky skin and oval shape. Her very low-cut dress and the pearls in her ears and round her neck and wrists denote that she is a courtesan.

The meaning of pearls
Whereas in the Middle Ages a pearl was a symbol of purity, by the 17th century it had become the attribute of the courtesan, or prostitute. As for the feather in the hat worn by the young victim, it symbolized a dissolute life.

A dangerous game
Cheating at cards was a risky business at the time, for had the cheat been caught, he could have been excommunicated or even sent to the galleys.

Her almost spellbinding gaze follows the direction of her finger, which is pointing at the cheat. It soon becomes obvious that these three people are accomplices, despite the fact that their eyes do not meet. They are in league against the adolescent seated on the right, and they communicate with each other in sign language.

The young man is so absorbed by his hand that he misses what is going on. And yet not only is his fortune at stake, but also his soul, for he is surrounded by three cardinal temptations: wine, women and gambling.

a clever piece of staging

To make the scene appear even more dramatic, La Tour used all the tricks in the painter's book. He took his figures to the very edge of the frame, and used aggressive lighting and violent colours. The reds, yellows, and greens accentuate the contrast between the dark background and the white faces. But above all, he involved the spectator.

Georges de La Tour belongs to a group of painters called "Realists", chief amongst whom was the Italian painter Caravaggio. But in this work La Tour was not attempting to portray the real world of gambling; he went beyond the visible into the symbolic, transforming his painting into a parable. Gamblers often had a symbolic role in painting. In Crucifixion scenes especially, the soldiers at the foot of the cross were often shown playing cards or dice, frequently with a skull nearby.

The Cheat holding the ace of Diamonds, detail. ▶

What chance does a lone adolescent have against three cheats who seem to understand each other without the need for words?

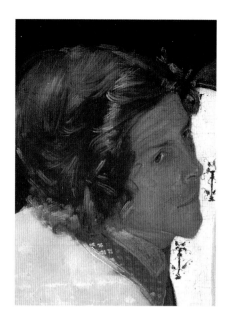
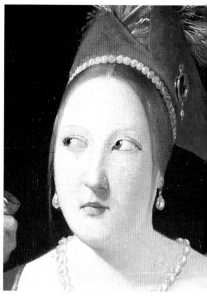

Georges de La Tour generally gave his paintings a hidden meaning. Underneath the disguise of the game of cards in *The Cheat*, lies a parable. Some scholars have even read a Biblical meaning into it. The adolescent is the prodigal son who leaves his home to go through all sorts of adventures before redemption.

subjects in disguise

By the same token, La Tour would paint a religious scene as if it was an everyday event, as he did in *Christ with St Joseph in the carpenter's shop*, for instance. If one compares the card-cheat's head with that of St Joseph, one can see that La Tour used the same very realistic technique for both. But the end results are not at all similar. The cheat has a complacent, slightly corrupt expression, whereas Joseph comes across as an old man full of benevolence. La Tour did not give him the traditional saint's halo, and his features are that of an ordinary man, marked by age.

Comparing the courtesan in *The Cheat* and the child in *Christ with St Joseph* is equally revealing. In both cases,

▲
The Cheat holding the ace of Diamonds, details.

There is another version of this painting called *The Cheat holding the ace of Clubs*, which was painted a few years before this one. The overall composition is similar, but there are many differences in details, especially in the positioning of the figures.

Georges de La Tour
Christus with St Joseph
in the carpenter's shop
(*c.* 1640), details.
Oils on canvas:
137 x 101 cm. ▶

La Tour simplified his lines and stylized the faces. The oval of the courtesan's face is drawn in a single line, as is the child's profile. And yet the two characters have opposite meanings. The courtesan represents danger and is a menace to the adolescent. The child facing the old man symbolizes hope and the future. How did La Tour achieve such different atmospheres?

it is all in the lighting

Whereas the figures in *The Cheat* are lit from the exterior, in *Christ with St Joseph*, the painter makes the light leap up from inside the painting. The warm glow that comes from a candle held by the child partially lights up the night and floods his face. Thus it is he, Jesus-Christ, who is the source of light. It is not necessary to give St Joseph a halo, the mere fact that he is bathed in this divine light makes him into a saint.

This is how La Tour managed to give a religious scene the intimate atmosphere of a genre painting. By manipulating light, by making it realistic at times and stylized at others, he suggested a mystical world.

Jan Fyt
(1611-1661).
*Game and hunting
gear discovered
by a cat*
(*c.* 1640/1650).
Oils on canvas:
95 x 122 cm.

The artist has
rendered the softness
of the fur and feathers
beautifully. One
living creature in
this still life: the
prowling cat. ▼

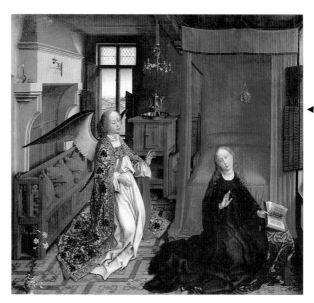

◄ **Rogier van der
Weyden**
(1399/400-1464).
The Annunciation
(*c.* 1435).
Oils on wood:
86 x 93 cm.

The *fleur de lys* is
the attribute of the
Archangel Gabriel.
It symbolizes purity
because of its white
colour and the Trinity
because of its three
corollas.

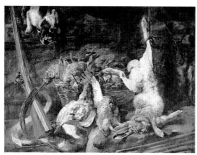

Jan Davidsz de Heem ►
(1606-1683/84?).
A table of desserts
(1640).
Oils on canvas:
149 x 203 cm.

What a delicious
banquet...but the
peeled lemon and the
half-eaten pie are
there to remind
one that time is
passing by.

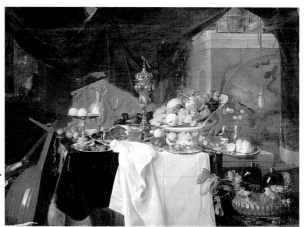

The still life

A still life is a painting that is without people. In French a still life is called a *nature morte*, a "dead nature", which is a strange name to use to describe Nature, which is by definition, "living". The term only dates from the middle of the 18th century in France, before that they were called "resting nature" or "motionless objects". The English name "still life" is derived from the Dutch "stilleven", or "motionless life". But "still" has another meaning, "silent", and this seems more appropriate to describe the bouquets of flowers, piles of fruits, haunches of venison and the full array of the huntsman's bag that constitute a still life painting.

Still lifes already appeared in religious art of the 15th century. In *The Annunciation* by Rogier van der Weyden, for example, painted in 1435. Like all the Flemish painters, Van der Weyden paid great attention to the details in his paintings: the open book, the ewer on the cabinet, the oranges on the chimney piece and especially the blue and white porcelain vase standing on the tiled floor.

However, still lifes did not appear as a separate subject until the 17th century, at the same time as genre painting. "I take as much trouble over painting a vase of flowers as I do over painting a face", said the Italian painter Caravaggio at the end of the 16th century. His contemporaries were scandalized. How could anyone dare to compare the art of painting a face with that of painting a mere flower! A few years later, nobody was shocked by the importance given to still lifes.

The still life originated in Flanders and Holland. Major painters like Rubens or Rembrandt painted still lifes, each treating them according to

Jean-Siméon Chardin ▶
(1699-1779).
Still-life with jar of olives (1760).
Oils on canvas:
71 x 98 cm.

At the 1763 Salon,
Diderot was the first
to notice the real
talent for the genre
of the painter of this
little "silent life",
and to admire
"the harmony
of the colours
and reflections."

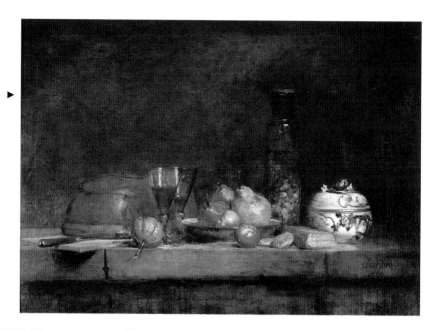

▲
Luis Meléndez
(1716-1780).
Still-life (1760/70).
Oils on canvas:
40 x 51 cm.

A peasant meal
against a dark
background,
simplicity seen
through Spanish eyes.

Eugène Delacroix ▶
(1798-1863).
Still-life with a lobster
(1824/27).
Oils on canvas:
80,5 x 106,5 cm.

The bright, warm red
makes Delacroix's
canvas vibrate with
life.

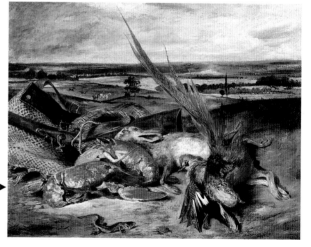

his taste and temperament. The jolly Dutch burgomasters particularly like paintings of "lunches", with the result that a great many painters were to specialize in painting them: Claesz, Heda, Kalf and Davidsz de Heem...
The fashion for painting still lifes quickly spread throughout Europe. Its most representative painters in France were Baugin in the 17th century and Chardin in the 18th. The best-known Spanish still life painter is Luis Meléndez.

Knowing how to paint a still life meant, of course, knowing how to reproduce objects as faithfully as possible. It requires great talent to paint the velvety surface of a peach, the transparency of a crystal decanter or the dull shine of metal. But still life painters often wanted to do more than reproduce objects, they wanted to express ideas through them. They would paint an hourglass to denote the brevity of life, or a musical instrument to express the pleasure of it... An object therefore took on a symbolic meaning, which the spectator has to know before he can fully understand the subject of a painting. This kind of still life was called a "vanity".

During the 18th century, the symbolic meanings of the still life were slowly lost and by the 19th century no artist would paint them exclusively. The *Still life with lobster*, which Delacroix painted in 1824, is an exception. It is the last major still life of the 19th century, and it can be said that, until Cézanne revived it in the 20th century, artists lost interest in the genre.

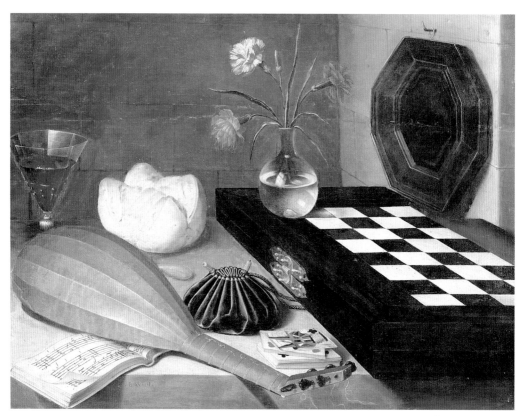

▲
Lubin Baugin,
French painter
(1612?-1663).
*Still life with
chessboard*
(c. 1630/35).
Wood panel:
height: 0,55 metres,
width: 0,73 metres.
Signature at the
bottom left hand
corner, on the edge of
the table. Purchased
by the Louvre in 1935.

BAUGIN

painter of hidden mysteries

Who is Lubin Baugin? His name is not even in French reference books, and yet he is the greatest French still life painter of the 17th century.

Glass is solidified breath. . . . It is a mouth that is eternally open to the heavens.

Paul Claudel, *The Magic of Glass*, in *The Listening Eye*.

Practically nothing is known about Baugin's life. In 1634, when he was about 22, Baugin stayed in Italy, where he came under the influence of Guido Reni, which earned him the nickname of "Little Guido". At the age of 40 he entered the French Royal Academy of Painting. And that's about it.

Not much more is known about his works, for most of them are as yet to be discovered. All that has been found to date are a few religious paintings and four still lifes, all of them small. The Louvre has two of them, *Still life with wafers* and the one illustrated here, *Still life with chessboard*, painted around 1630 or 35.

what are these commonplace objects hiding?

There are all sorts of still lifes: rich ones, voluptuous ones, austere ones, greedy ones. Baugin's *Chessboard* could be qualified as plain, sober and reserved.
This is not a "repast" or a "floral arrangement", both classic subjects. At first glance, the objects on the table have absolutely nothing in common. But they clearly were not placed there haphazardly. Someone laid them out with care and for a very precise reason. What is it?

The Royal Academy of Painting
This was an academy at which one learned the basic rules of art. The artist was accepted after he had presented a "submission" piece. He was taught art theory (anatomy, perspective, history) and did atelier work. Every year two artists were awarded the *Prix de Rome*, a grant that enabled them to continue their studies in Italy.

69

how did Baugin arrange the objects in his painting?

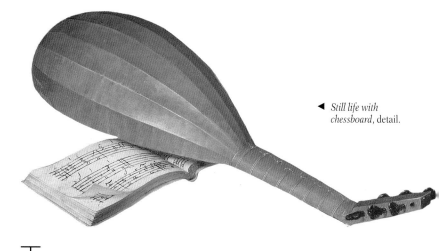

◀ *Still life with chessboard*, detail.

The tradition of painting objects from daily life goes back to the 15th century. The loaf of bread, the musical instrument, the score, the purse, the playing cards, the chessboard, the bunch of flowers and the glass of wine were all objects commonly found in a 17th-century household. A still life was also a piece of theatre: the setting and the props of life.

eat, drink, and be merry!

Baugin placed his objects on a table pushed into a corner. The spectator sees the scene from above-right, the light shines from the left. By composing his painting this way, Baugin constructed a subtle network of diagonal lines.

How disorderly it all looks! The open, dog-eared score, the mandola and the closed chess-board overlap the edge of the table, all pointing in different directions. The pack of cards by the neck of the mandola is not neatly stacked, it looks as though someone had just put it down. Was it the same person who laid the obviously well-filled green leather purse alongside them? And why the gleaming pearl drop just behind it?

The eye of the spectator is led back and forth from object to object. Starting from the left-hand fore-

A mandola
This musical instrument, which symbolizes hearing, is a six-stringed luted mandola and not a lute, which has 19 or 21 strings. Mandolas were often played by women and have a very sweet sound.

The flowers
Three carnations with an intoxicating perfume to represent the sense of smell and the vanity of perishable things.

The *Prix de Rome*
This was the highest competition award given to promising young artists by the Royal Academy so that they could finish their studies in the Academy's establishment in Rome, which has been in the Villa Medicis since 1803.

ground, the chessboard, the flowers, the wine and the bread lead the eye towards the background.

Why did Baugin choose to paint those specific objects? Because each of them had a special meaning for people in the 17th century.

the five senses

The mandola and the score evoke music, they speak to our ears. The bunch of carnations, a strongly scented flower, is for our sense of smell.

The bread and wine make us hungry and thirsty, our sense of taste is aroused. The hexagonal object hanging on the right-hand wall that looks like a pewter plate is in fact a mirror. It attracts our eye. As for the cards, the purse and the pearl drop, they evoke the sensory pleasure of touch.

Thus each object has a specific meaning. Baugin's still life is an allegory of the five senses.

The glass
Baugin uses it to symbolize one of the five senses, taste.

life is but a vanity

For a long time art historians were satisfied with this interpretation of Baugin's painting. It must be said that still lifes that alluded to the five senses were very fashionable in the 17th century.

They were generally philosophical paintings called "vanities". There are no people in this kind of painting, and yet everything speaks of the presence of man. A vanity illustrates the fragility of life. It tells one that the pleasures of the senses are temporary, that they will disappear with the passing of time and that they are therefore vain and futile. This is why Baugin painted a half drunk glass of wine, a loaf of bread that will soon go stale, flowers that will inevitably fade.

Throughout the century still lifes continued to evolve, containing fewer and fewer objects. This austerity was meant to make one reflect on the real meaning of life.

The pack of cards
They signify both the sense of touch and futile pastimes.

An allegory
An allegory is the illustration of an abstract idea through the representation of a concrete person or object. One of the most frequent allegories is of Death: a skeleton brandishing a scythe.

71

what is the hidden meaning of Baugin's painting?

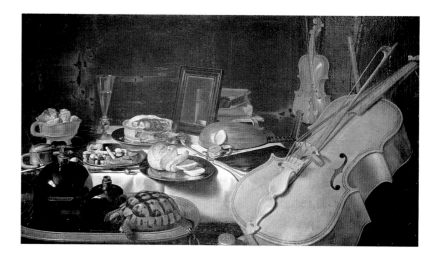

A Jesuit scholar called Ménestrier once said that a painting was "a silent speaker who explains without uttering a word". And indeed there is a whole language of the image. How can one learn it? A number of scholars have studied it, and by examining people's habits at different periods in history they have discovered the real meaning of certain ancient symbols.

There are a lot of similarities between Baugin's painting and this Dutch "vanity". There are the musical instruments symbolizing hearing, cakes and wine for taste, a mirror for seeing. The tortoise is a somewhat unusual symbol for the sense of touch...

death is never far away

Let us look at *Still life with chessboard* again. We know that the mandola is a woman's instrument, and the pearl drop, symbol of the courtesan, confirms her presence.
The first card in the pack reveals the presence of a man. Jack of Clubs on a Hearts card: the man is in love. The purse lying between the cards and the mandola implies financial transactions between the man and the woman.

In Christian iconography, the bread and the wine are the body and the blood of Christ. A carnation means pure love. These three components also attract the light. They are the only warm notes among all those cold colours. The Church condemns riches as it condemns gambling.

Iconography
Iconography is the choice of recognizable images that a painter selects as components of his work. The word is derived from the Greek *eikon*: image and *graphein*: write, or describe. The study of the meaning of these images is called "iconology", from *eikon* and *logos*: knowledge.

72

As for the mirror, it represents vanity. But this mirror is disturbing because there is nothing reflected in it. This is because it also symbolizes death, which puts an end to all vanities.

Therefore this painting is not just about the five senses. The painter is suggesting two ways of life.

One of them is solely devoted to pleasure. It is ephemeral and condemned to death. The painter placed the mandola, the cards and the bag that symbolize it in the foreground and tilted them downwards.

The other embraces higher things and is turned towards religion. It is only thus that man can grow. Baugin places its symbols in the middle-ground, at the apex of the triangle that contains his composition.

So a simple still life is transformed into a religious painting without people.

not purely for pleasure

This analysis may seem farfetched, but in the 17th century it was unthinkable to simply paint a group of objects for the fun of it. Still lifes weren't considered to be "noble" subjects in themselves, a painter used them to express his view of life.

Who taught Baugin how to paint still lifes?
During the 17th century a group of Flemish painters settled at the Confraternity of Saint Germain des Prés, in Paris. It is likely that one of them, Van Boucle, taught Baugin this new form of art.

Georges Braque
Still-life with guitar (1927).
Oils on canvas:
81 x 116 cm.

In the 20th century painters still produced still lifes, but the objects had lost their earlier symbolic meanings. From Cubism (1907) onwards, both Picasso and Braque frequently painted guitars. They were primarily interested in shapes.

73

▲

Paolo Ucello
(1397-1475).
*The Battle of San
Romano* (c. 1450/56).
Oils on wood:
180 x 316 cm.

The horses look more
like wooden horses on
a roundabout, but
what a powerful
painting!

Andrea Mantegna
(1430/31-1506).
*Wisdom triumphant
over the Vices*
(c. 1502).
Oils on canvas:
160 x 192 cm.

The Greek goddess of
Wisdom was Athena,
whom the Romans
called Minerva.

74 ▶

History and
mythology

During the reign of Louis XIV, the Royal Academy of Painting decided to classify painting by subject. It used two criteria, the importance of the subject and the difficulty it presented to the artist. Out of this there arose one style that overshadowed all the rest: the historical painting. It was called the "grand manner".
It included ancient and modern history, biblical subjects and mythology.

One of the first-known historical paintings dates from the 15th century. In 1452 the rich Florentine family of the Medici commissioned the Italian painter Paolo Ucello to decorate its palace in Florence with illustrations of the war against Siena, which Florence had won in 1432 with its help. Painting a battle is a complicated matter, because it entails a composition containing a great many men and horses. But it was a perfect subject for Ucello, who had spent much time studying perspective.

The Renaissance was very much influenced by the rediscovery of Antiquity, out of which arose new subject matter for painting, the stories of the Greek and Roman gods, or "mythology". It was a wonderful source of inspiration both for the painter, who could extract powerful, noble subjects from it, and for the Humanist public of the time, which was flattered to be among the "initiates" capable of understanding them. Mythology also gave the artist a chance to paint the naked body without offending public morals.
Very soon painters began to combine history and mythology, especially since it was often more convenient to "disguise" a well-known personality as a mythological one! Thus *Diana, Goddess of the hunt*, by the Fontainebleau School, is in reality a "hidden" portrait of Diane de Poitiers, King

◀ **Antoine Caron**
(1521-1599).
The Massacres of the Triumvurate (1566).
Oils on canvas:
116 x 195 cm.

Roman history was merely a pretext here to denounce the cruelties of the religious wars of the middle of the 16th century.

▲
Nicolas Poussin
(1594-1665).
The Inspiration of the poet (c. 1630).
Oils on canvas:
182 x 213 cm.

Poussin favoured calm and meditation over movement and clarity over confusion.

Petrus Paulus Rubens
(1577-1640).
Marie de Medici disembarking at Marseilles (1625).
Oils on canvas:
394 x 295 cm.

A historical episode seen by Rubens: reality and mythology are mixed for the greater pleasure
◀ of the eye.

Henry II of France's mistress. The nudity of the goddess made her timeless, but it also gave pleasure to the king, enabling him to bring his clandestine love into the "broad light of day".

In the 17th century, historical painting was more or less abandoned in favour of genre painting. Nevertheless, it was the period in which the Flemish painter Rubens portrayed the salient events in the life of Marie de Medici, Regent of France, in a series of 21 paintings painted at the Luxembourg Palace between 1622 and 1625, known as "Marie de Medici's Gallery" (now in the Louvre). He created a new style known as "Baroque", after the Portuguese *barroco* signifying an irregular pearl. With its flaming colours, exuberant forms, and swirling lines, Baroque painting was the exact opposite of the calm balance of Classical painting, in which line was more important than colour.

Nicolas Poussin is the most important exponent of French Classicism. He took the inspiration for his paintings from mythology and the Bible, accentuating the "nobility" of the subject in order to "elevate" the spectator's soul.

In the 18th century historical paintings became more decorative and "pleasing to the eye". *Diana Bathing* by Boucher is a good example. The "grand manner" resurfaced at the beginning of the 19th century with the Neo-classical and Romantic movements. Neo-classical painters such as David again took their inspiration from Antiquity, while Romantic painters such as Delacroix and Géricault painted contemporary subjects.

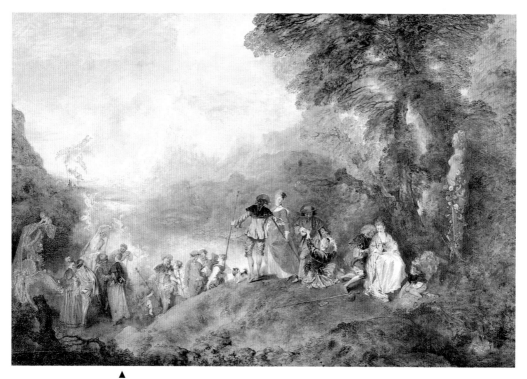

▲

Jean Antoine Watteau,
French painter
(1684-1721).
The Pilgrimage to Cythera (1717).
Oils on canvas:
height: 1,29 metres,
width: 1,94 metres.

This painting has been in the Louvre since 1717, the year in which it was painted. In 1712, Watteau was accepted by the Royal Academy of Painting. According to the rules, he had to produce a "submission piece". He produced *The Pilgrimage to Cythera* which took him five years to complete.

WATTEAU
painter of the ephemeral

Even though we don't know who those people are, nor where they are going, one thing is clear: Love is king of the castle. Watteau painted a world in which pleasure was the driving force.

Where is Cythera?
Cythera is an island in the Ionian Sea. According to Greek mythology, it is where Aphrodite, goddess of love, whom the Romans called Venus, was said to have settled.

The atmosphere is full of gaiety. The scene is taking place in an apparently wild countryside that has nothing in common with the formal gardens of the palace of Versailles, the usual setting for Court picnics. It is early Autumn and the golden leaves are still thick, but the light has lost its brilliance. Elegantly dressed men and women are disporting themselves in the milky haze. A number of couples are getting ready to leave and a boat awaits them. Are they leaving Cythera or have they already reached their destination? Impossible to say, but there is a dawning feeling of regret in the scene.

let us talk of love

A statue stands at the edge of the wood, it is armless, but it is garlanded with roses and a quiver, symbol of Cupid, has been placed at its feet. The statue is of Venus, goddess of love. On the other side of the painting, some *putti* flutter in the air above the boat. All of this establishes the subject of the painting: Love.
When the Academy of Painting accepted the work from Watteau, it changed the title from *The Pilgrimage to Cythera* to *The Fête galante*. The selection board had immediately perceived that Watteau was a painter who celebrated pleasure. This tag of "painter of bucolic pleasures" was to stay with him throughout his life.

A *fête galante*
According to a French 16th century dictionary, a *fête galante* was a "gathering of honest men in pursuit of pleasure". A "gallant" was "a man who has the air of a courtier, attractive manners, and who wishes to please". A "gallant woman" was "a woman who knows how to live, how to choose her companions and entertain them well".

79

was Watteau painting his own day?

Three couples attract our attention. A little Cupid sits by the statue of Venus. He is trying to attract the attention of a seated woman by pulling at her white skirts. His efforts are in vain, however, for she is so captivated by the man kneeling at her right that she even seems unaware that she is holding a fan. Near them another couple is getting ready to leave. The third couple is already on its way, but the woman seems undecided, and has turned to look back. Her partner, who has his back to us, is holding her round the waist and gently leading her away. At their feet a little dog frisks impatiently.

Love set to music
Cythera was very fashionable in the 18th century. In 1702 a play by Dancourt, *The Three cousins*, was performed at the Comédie Française. It ended with a song:
"Come to the island of Cythera
On a pilgrimage with us,
Young girls leave it never
Lest with a lover or a spouse."

dancers and actors

▲
The dog
Man's best friend, it symbolizes fidelity.

Auguste Rodin, the 19th-century sculptor, thought that there was only one couple in this painting, captured at different moments. The man propositions the woman: that is the seated couple. The woman thinks about it and then accepts: she stands up. Once she is on her way, she looks back a little regretfully at the past. This is how Watteau captured the ephemeral.

If one takes a closer look at the people in *The Pilgrimage*, one notices that their clothes are of satin, as shining and silky as a theatrical costume, and that their movements

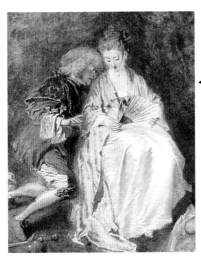

◄ The Pilgrimage to Cythera, details.

Theatre people
The three couples in the painting are very much inspired by the theatre. At the beginning of the 18th century, the theatre, especially Italian comedy, was very fashionable.

▲
Putti
These plump little angels symbolized love and were called *putti* in Italian, from the Latin *putus*: boy.

remind one of dancers. Watteau had trunkfuls of stage costumes in which he loved to dress his models.
He loved the theatre and drew a lot of his inspiration from it. When he arrived in Paris in 1702, he discovered a whole new repertoire of subjects, thanks to the painter Gillot, in whose atelier he worked. From then on his models were singers, dancers and actors.

charm of the intimate supper

In this painting, Watteau evokes a carefree life that seems to be outside reality. This is because Court life changed a great deal in the 18th century. After the pomp of the Sun King's court at Versailles, and the hardships brought by his European wars, the nobility felt the need of a gentler way of life. Tiring of the grandeur of the chateaux, it turned towards the intimacy and comfort of private houses. The fashion was for the theatre and the "intimate suppers" that followed it, at which they drank a brand new concoction called champagne.
Thus Watteau was indeed describing the pleasures of life in this painting, but he was by no means being light and frivolous. Love is shown as an ephemeral emotion that can also be deep and long lasting, denoted by the presence of the little dog.

81

how was Watteau's painting restored?

Early books reproduce quite a surprising *Pilgrimage to Cythera* compared to the painting as it is today. Until recently, the painting had a thick coat of varnish that had gone a yellowish-brown with age. The painting needed to be restored to its former glory.

restoration: a surgical operation

To diagnose its condition, the painting was subjected to a number of examinations. It was lit with a beam of oblique light and enlarged ten times with macrophotography. Pentimentos were discovered under infra-red light, and retouching under ultraviolet light.

X-rays showed the composition of the painting, the stages in which it was painted, the alterations in the composition and the thickness of the pictural layer...

The restoration of Watteau's painting was completed in 1984, after several years' work. It was necessary to "lighten the varnish", in other words, to remove a fine coating of it. This operation revealed an unsuspectedly

Pentimentos
Watteau's use of a binder rich in oil enabled him to work very fast. At times he would make corrections by simply painting over the parts he wished to alter. These are called "pentimentos", literally "repentances" in Italian. Pentimentos are invisible to begin with, but a few decades later the altered parts often become visible. The *putto* below the hill has changed place twice!

Retouches
These are alterations made by someone other than the artist.

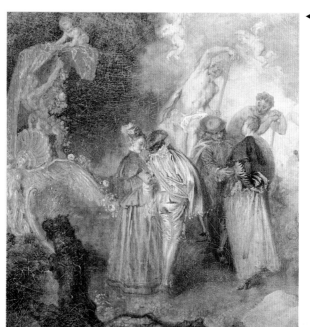

◀ *The Pilgrimage to Cythera*, detail.

Departure for Cythera, ▶ detail.

rich range of colours. The sky, which had appeared yellowish, turned out to be a blue-tinted white with touches of pink and pale yellow. The clothes which seemed dark green and red are in fact light pink and blue-green.

a vibrant touch

The touch
This is the painter's method of painting, the way in which he applies his colours. It is the "signature" of the artist. Watteau, for example, is recognizable by his slightly grubby colours, because he rarely cleaned his palette. Watteau's "touch" greatly influenced the Impressionists in the 19th century.

The ochres of the foreground and the way in which the distance fades to blue remind one of the landscape behind the *Mona Lisa*. Watteau's painting has the same light and vaporous atmosphere. But contrary to Leonardo da Vinci who blended his contours in order to make his brushwork invisible, Watteau did not hide his "touch". His brush-strokes are very visible.

Like Da Vinci, even though his techniques were different, Watteau never "described". He sketched, he suggested, he presented our imagination with a delicate world. His paintings often have a misleading air of being "unfinished", but this was in order that the imagination should do its share.

The Berlin mystery
After he finished *The Pilgrimage to Cythera*, Watteau painted *Departure for Cythera*, now in Berlin. It is the same size and has a very similar range of colours, but it has lost its spontaneity. When painting the leaves on the trees, for example, Watteau no longer used the light brush strokes that let the canvas show through. Instead he used fine, closely spaced touches of thick paint. He is describing and not suggesting, as he had done in the earlier painting.

▲
The Pilgrimage to Cythera, detail.

83

Jacques-Louis David,
French painter
(1748-1825).
The Oath of the Horatii
(1784-1785).
Oils on canvas:
height: 3,30 metres,
width: 4,25 metres.
Commissioned from
the artist by
Louis XVI.

◄ **David**
Study for the figure of
Sabine in *The Oath of
the Horatii*
(before 1826).
Lead pencil
highlighted with white
on grey paper:
46,5 x 51 cm.

DAVID
painter of the ideal

*The only way to
achieve grandeur,
and, if possible, the
inimitable, is by
imitating the Antique.*

J. Winckelmann,
theoretician of the
Neo-classical school

Here is a painting whose subject one can easily guess without knowing the story! Swords, helmets, brave soldiers, weeping women: David has painted war, patriotism and heroism.

A few years before the French Revolution, Louis XVI commissioned this painting from David. The king wanted a work that was powerful and expressed nobility and morality in order to elevate the spectator's mind. The painter therefore decided to take a subject from Antiquity and left for Rome, where he had studied art for five years, in search of an "atmosphere of antiquity".

to give one's life for the Nation

David chose a subject from Roman history that had been made famous by one of France's major playwrights, Corneille, in a tragedy called *Horatius*. Three brothers, the Horatii, swear an oath to their father pledging their lives to their nation, Rome, in the war with the neighboring city of Alba. In Alba, the Curiatii brothers swear the same oath. The weeping women are in the state of tragic torment that characterized the work of Corneille. The blonde Sabine is married to the eldest Horatius, but she is also the sister of the Curiatii. The brunette Camille is the sister of the Horatii, but she is engaged to a Curiatus. The play ended very tragically: there was a single survivor, a Horace, who killed his sister Camille on his return to Rome because she mourned her Curiatus betrothed. When David returned to Paris, it was a triumph: *The Horatii* was acclaimed as a revolutionary painting.

What is an atelier?
An "atelier"
(workshop) was an
artist's studio in which
assistants and
apprentices received
instruction from the
master and
contributed toward
the execution of a
work bearing his
signature.
David was awarded
the *Prix de Rome* at
the age of 26, at his
third attempt. After
this brilliant start to
his career, he became
a member of the
Academy, and was the
"master" of a major
atelier in Paris.

85

what
makes
David
typical
of the
Neo-
classical
school?

W hy did David choose Rome in which to paint this work? Because a lot of very interesting things were going on there at the end of the 18th century.

the craze for Roman Antiquity

The Rococo style that so characterized Watteau had gone out of fashion a few years earlier. It was thought to be too decorative and pointless. The latest trend was for "virtuous" painting that moved the spectator and elevated his soul. This new ideal of beauty was found in Greek and Roman Antiquity, and Rome therefore was at the hub of the movement, which was called Neo-classicism. It later spread all over Europe.

The "atmosphere of antiquity" that David had sought for *The Oath of the Horatii* strikes one immediately. The scene is taking place in a sort of courtyard. The three arches in the background, the rough-hewn capitols of the columns and the paving on the ground suggest the ruggedness of Roman architecture.

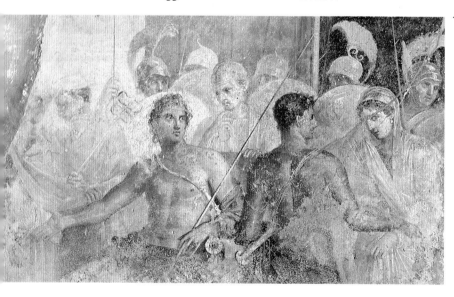

◀ **Anonymous**
*The Abduction
of Briseis*
Fresco from Pompeii,
detail.

The figures in their Roman garments are typical of this new style in art: their faces express no emotion, but their striking attitudes speak for themselves. The men, standing with one leg thrust forward and raising their muscular arms, are the very incarnation of masculine energy. The drooping posture of the weeping women further enhances the bravery of the men, making them into true heroes of Antiquity.

David painted an abstract idea

David accentuated this contrast by giving his painting a formal structure. Once again, the composition is in a pyramid, or triangle, providing balance and calm. The painting is composed of a large pyramid formed by the group of male figures, in which there are two smaller ones formed by the sons on one side and their father opposite them.

On the right, the group of women is composed in the same double framework, but the pyramids are smaller, as if they had collapsed. How did the emotion of this painting manage to come through all this rigid geometry?

David's "pictorial language" is effective because it is clear and simple: he was not speaking to our senses, nor was he trying to provoke or represent emotions. Everything in his painting is logical.

Being a commission from the king, his painting was supposed to put across heroism and patriotism; above all, it had to impress his audience.

The Oath of the Horatii lived up to these expectations, and as well as being very popular, it is a prime example of Neo-classical painting.

David
The Rape of the Sabine Women (1799), detail.
Oils on canvas:
385 x 522 cm.
▼

▲
Anonymous
Warrior, called the *Borghese gladiator* (1st century B. C.).
Marble: 1,99 m.

87

what technical difficulties did David come up against?

D avid's painting is of an impressive size: 3,30 metres in height by 4,25 metres in width, and the figures are life-sized. Producing a work of these dimensions was no mean affair.

enlarging a preliminary sketch

Paintings of this kind were usually created piecemeal. For his part, David first made studies of the major scenes and the grouping of the figures. Next he made a

David
Studies for *The Oath of the Horatii*.
Stumped pencil with highlights in white chalk.
The father: 58,8 x 36,2 cm.
Camille: 50,5 x 35 cm.
▼

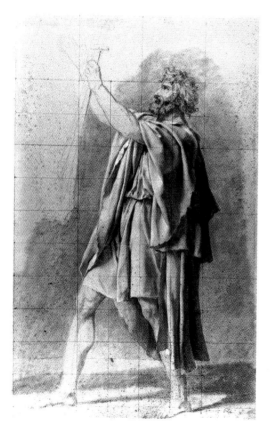

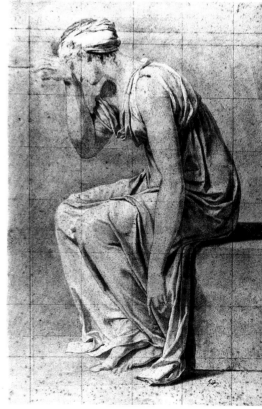

The Oath of the Horatii,
detail of the elder Horace's foot.

David started over twenty-five times before he was satisfied with this foot.

detailed sketch of the complete composition, which he then painted on a small canvas. After that, it was necessary for him to enlarge this to the required size. David's pupil, Drouais, transferred the small painting onto paper, and then enlarged it onto the upright canvas. He did this by drawing a grid and then enlarging the contents square by square. He transferred all of the painting except for the figure of the elder Horace, whom David wished to paint himself.

line dominated colour

David was more interested in line than in colour. He took a lot of trouble over the draperies. What a vigorous line he has! He enclosed the colours in shapes with very distinct contours. This gives his painting great clarity.

He also completely schematized the colours, giving them a symbolic rather than a decorative role. The men are wearing bright primary colours, red, blue and yellow, the women are wearing the same colours, but they have been toned down so as to become muted.

Enlarging a sketch
▼

David's paintings are a mixture of the grandiose and the simple. In each of them, he captured the essential and made himself easily understood by everyone. This is doubtless the reason why he was so frequently commissioned to paint the major events of his day.

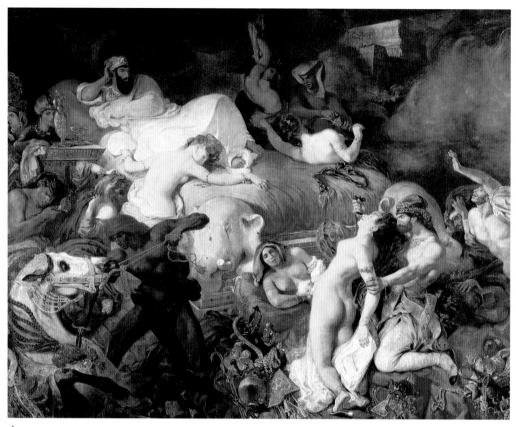

▲
Eugène Delacroix,
French painter
(1798-1863).
*The Death of
Sardanapulus* (1827).
Oils on canvas:
height: 3,92 metres,
width: 4,96 metres.
Purchased by the
Louvre in 1921.

◀ **Eugène Delacroix**
Study for *The Death
of Sardanapulus,
Sardanapulus and
other characters.*
Pen, sepia ink:
23,8 x 30 cm.

DELACROIX

painter of passion

Brutality, confusion, explosions of colour, there are some violent emotions in this painting! When Delacroix exhibited it in 1827, it was considered scandalous. Not a trace of the order and serenity people had learned to expect from Classical painting. The Death of Sardanapulus was the triumph of unbridled passion.

Who was Sardanapulus? According to legend he was a king in ancient Asia who was cruel and loved pleasure above all. He surrounded himself with the young and had a large harem. "One day", Delacroix explained, "rebels besieged his palace. Lying on a magnificent couch on top of an immense pyre of logs, Sardanapulus ordered the killing of his women, his pages and even his horses and his favorite dogs. Nothing of all that had given him pleasure was to be allowed to survive. A woman who refused to be put to death by a slave hung herself from the columns supporting the vaulted roof. Lastly an official set fire to the pyre and threw himself into it."

What was this fascination with the East?
During the 19th century, the East became a great source of inspiration. Ever since Napoleon had been to Egypt as a young general in 1798, and the archeologists who had accompanied his army had brought back ancient Egyptian artefacts, the French had been fascinated by this world of shimmering colours and costumes. This fascination spread to England when it took Egypt from Napoleon shortly afterwards, and in 1821 the poet Byron published _Sardanapulus_, from which Delacroix drew his inspiration.

emotion brought to the surface

Delacroix was familiar with this tale. It had much to recommend it as a subject: it had never been painted, it took place in the mysterious East, and it was overflowing with violence and wild passion. Delacroix was never a fan of gentle and restrained painting, of "noble simplicity and calm grandeur". The French poet Baudelaire said of him that "he is passionately in love with passion". In Sardanapulus, Delacroix had found an ideal subject.

Did Delacroix visit the East?
His first visit to the East was to Morocco in 1832. He brought back a great many artifacts which are now in the Delacroix museum in Paris.

91

how did Delacroix create this maelstrom?

T he eye sweeps diagonally across the painting to the woman being stabbed at bottom-right. It is guided by the light coming from the left and running along the edge of the couch without touching Sardanapulus' face.

The Death of Sardanapulus, details.

fire red, blood red

The scene is Pandemonium. Each figure fights and struggles in a tortured pose. In the right-foreground a brown-haired woman collapses under the blows of a knife, her body arching convulsively. On the left, a white thoroughbred rears away from a black man whose body also arches as he drags the horse towards the centre of the canvas. All these curving lines coiling round each other into the background of the painting create the impression of an uncontrollable maelstrom.

There is a corresponding contrast of colours to this contrast of movement: the white horse, the black man, the red turban. But there is one colour that dominates all the rest, and that is red. It floods across the painting like a spreading fire or a river of blood. One can feel the heat and guess the presence of the pyre on which everyone is to be consumed. But, strangely enough, there is hardly a

Sardanapulus
Here is the cruel tyrant Sardanapulus' face. In fact, Delacroix gave him his own face! Disguised self portraits were very fashionable at the time.
▼

▲

The woman being stabbed
Warm, vibrant colour, curving lines, these are what give the scene its dynamism.

The still life
When he painted *Sardanapulus*, Delacroix had not yet visited the East; he had seen these artifacts at a painter friend's home. ▶

92

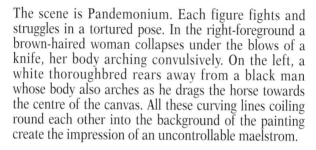

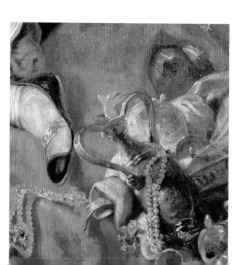

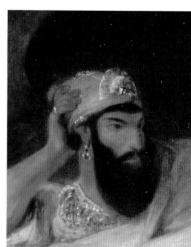

▲
The black man and the horse
Everything is in opposition here: the colours, the movements...It is the triumph of violence.

flame in the painting, and not a single drop of blood. Delacroix did not illustrate this massacre, he suggested it. Delacroix placed a pile of precious artefacts in the middle of the chaotic foreground: a quiver, arrows, jewels, a vase, weapons... What is this still life with its iridescent colours doing there? It was there to indicate where the action was taking place, in the East.

▲
The dead blonde-haired woman
This dead woman with her hair undone had brown hair in the cartoon. But Delacroix altered this to blonde in the final painting, in order to favour warm colours.

a romantic hero

Perhaps the most amazing thing in this painting is the contrast between the shadowy figure of Sardanapulus and the aggressively-lit tumult going on all around him. Sardanapulus is impassively contemplating the massacre he ordered.

The poet Baudelaire was especially impressed by this figure: "Can a painted figure ever give a more comprehensive idea of an Eastern tyrant?" he asked. "Sardanapulus with his black-plaited beard dies on his pyre, draped in muslins and in a feminine pose."

An extraordinary painting...one gets the impression that one is only seeing a part of it: all the figures are cut off by the edges of the canvas. A man is thrust into the scene from the right. In contrast, the horse on the left looks as though it were trying to leave the frame. In the foreground the foot belonging to the woman being stabbed is pushing towards the spectator. In short, everybody is either entering or leaving the painting. By this method of composition Delacroix enlarged an already extremely large painting.

The truncated man ▲
Baleah, Sardanapulus' cup-bearer, lights the pyre and throws himself onto it.

93

how did the public greet Delacroix's painting?

◀ **Delacroix**
Study for *The Death of Sardanapulus*: foot of the slave with the dagger. Pastels on brown paper: 30 x 23,5 cm.

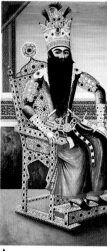

▲
Anonymous
The Shah of Iran, Qadjar dynasty.
Oils on canvas: 227 x 131 cm.

This painting was a gift to Napoleon's ambassador to Persia. What a difference between the East of the Romantics and the East seen by Oriental artists!

"They'll end up making me believe I've produced a real fiasco!" sighed Delacroix. For the critics had found fault with everything: the chaotic foreground, the woolly composition, the agitation of the scene, the apparently lackadaisical drawing. Delacroix had flouted every rule of Classical art.

In fact Delacroix was not a Classicist, but a Romantic. He believed that a painting should "stir up the emotions". Other painters such as Gros or Girodet had already rejected the rules of the Academy, but with *The Death of Sardanapulus*, Delacroix even upset the use of colour.

he invented coloured shadow

Delacroix was among the first to perceive that a colour is altered by another colour placed next to it. "The slightest green and orange arrangement produces a wonderful brilliance", he wrote.

Playing on these contrasts, he used pure, primary colours, saturating his canvas with warm, vibrating tones. He never used grey, for to him grey was the enemy of painting. To paint a shadow on a naked body, for instance, he would use ochre, or pink.

Delacroix's journal
Delacroix made his journal into a sort of manual. In it he wrote down ideas for paintings, technical notes, notes on his researches in colour and his impressions of other painters' work. He did not keep it regularly, but it is a precious document nevertheless, for the painter sometimes revealed genuine "secrets of the atelier".

94

The Death of ▶
Sardanapulus, detail
of the still life in the
centre foreground
(actual size).

This close-up helps
one to understand the
painter's "touch", his
audacious way of
using his brushes.
Broad, open strokes
made with a fine
brush placed without
hesitation, this is the
treatment that
characterizes the
art of Delacroix.

Pure colours
After painting a thick
layer of pure colour,
red for example,
Delacroix frequently
added a glaze; in this
case a lightly tinted
coat of varnish. ——

Detail ——
In certain areas,
Delacroix worked his
details richly.

*Perfumes, colours and
sounds respond to each
other.*

Baudelaire,
Correspondence.

The texture
For painting the
background, Delacroix
used a very diluted
oil paint that he
applied like
watercolour. For
the foregrounds,
he often used
a thicker paint.

Stippling
Delacroix applied
touches of pure
colour, here he used
yellow. "It is good", he
wrote, "that the brush-
strokes aren't blended
in reality, that they
should only blend
when one is at a
certain distance." This
allowed him to play on
the thicknesses of the
paint layers. The
fluidity of his paints
enabled Delacroix to
use the technique
called "stippling",
in which he applied
brush-strokes that did
not exactly follow the
contours of the
objects.

95

Nicolas Poussin ▶
(1594-1665).
Winter or *The Deluge*
(1660-1664).
Oils on canvas:
118 x 160 cm.

▲
Jan van Goyen
(1596-1656).
*River landscape with a
windmill and a ruined
castle* (1644).
Oils on canvas:
97 x 133 cm.

Claude Gelée,
called **Le Lorrain**
(1600-1682).
*The Disembarkation
of Cleopatra at Tarsus*
(1642-1643).
Oils on canvas:
119 x 170 cm.

Le Lorrain's
landscapes are
characterized by his
use of light. They are
bathed in a soft
tonality and the
horizon disappears
into infinity. Here the
historical subject is
dwarfed by a
spectacular Nature. ▶

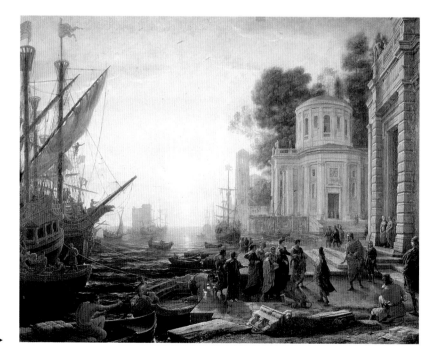

The landscape

Landscape painting was not always a separate genre, but landscapes have always been part of the painter's panoply. From the Middle Ages landscapes were used as backdrops in a great many paintings. They were used to situate a person in the world and not in heaven, to show a precise location or to convey an abstract idea.

In the 16th century, during the Renaissance, the landscape played an important role and reflected a new state of mind. Though it always formed part of the background of a painting, it generally served to underline the strong tie between man and nature. The landscape became the mirror of a cosmic civilization.

Towards the end of the century it was discovered that a landscape could be used to underline an effect or an emotion: a clear sky reinforced a happy scene, a stormy sky accentuated a strong emotion.

It wasn't until the 17th century that painters began to make nature the sole subject of their paintings. The Dutch were the first to acquire a taste for small landscape paintings, preferring familiar locations to distant, unknown countries. The demand was so great that many artists specialized in the genre, painting country scenes, sand dunes, canals, seascapes (Hobbema, Van Goyen, Van Ruysdael), views of the city (Vermeer, Berckheyde, Van der Heyden) or winter scenes (Avercamp).

During the same period in France, The Academy of Painting established a hierarchy in the genre, separating it into two kinds of landscape. At the top of the scale, there was the "heroic landscape", which it included in the "grand manner" of painting. This applied to historical or Biblical scenes

Hubert Robert ▶
(1733-1808).
*Imaginary view of the
Grande Galerie of the
Louvre in ruins* (1796).
Oils on canvas:
114 x 146 cm.

Here the Louvre
was "disguised" as
a Roman ruin during
the Neo-classical
period! Nature invades
the building, which is
a mere product of
man, and will end up
by engulfing it.

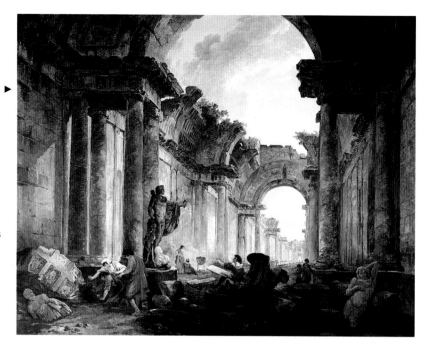

◀ **Joseph Mallord
William Turner**
(1775-1851).
*Landscape with a river
and a bay in the
background*
(*c.* 1835/40).
Oils on canvas:
93 x 123 cm.

Turner was a
painter of light and
atmosphere in motion.
In his landscapes one
cannot really
distinguish the
earth from the sky.
Everything has lost its
definition. The use of
pure colours (yellow
and blue in this
painting) and the
study of the
"ephemeral" make
Turner a precursor of
the Impressionists.

that were often set in landscapes with ruins reminiscent of Antiquity. In them nature was used to express an idealized beauty.

At the lower end of the scale, the Academy placed the "rustic landscape", country scenes sometimes containing figures, and generally full of life. These paintings were considered inferior because they didn't call for a knowledge of history or any great mastery of the laws of composition. Up to the beginning of the 19th century, they were always painted indoors, in the artist's studio, using sketches made at the locations.

In the 18th century, the popularity of the *fêtes galantes* and open-air entertainments encouraged the "rustic landscape". The formal gardens of Versailles were forgotten in favour of a wilder, truer nature.

In the 19th century, during the Romantic era, the genre was freed from a systematic idealization: the modern landscape had been born.
English painters in particular were deeply moved by the spectacle of nature. They painted open skies full of movement which they reproduced very accurately, and wild seascapes.
German landscapes expressed a feeling of unease, or melancholy. Faced with the landscapes of Germany, the painter felt dwarfed and lonely, as if he were facing his destiny. These landscapes are tragic.
In France, a number of artists, known as the Barbizon School, began to paint sketches in the open air, the better to capture reality. The final painting, though worked over in the studio, had a greater air of spontaneity. This school was to open the doors to one of the most celebrated movements in painting: Impressionism.

▲
Jean-Baptiste Corot,
French painter
(1796-1875).
*Souvenir de
Mortefontaine* (1864).
Oils on canvas:
height: 0,65 metres,
width: 0,89 metres.
Signed at bottom
right.
Purchased by the
Louvre at the 1864
Salon.

COROT
painter of nature

Some painters are attracted by a face, others by a historical subject. For his part, Corot was fascinated by nature. A simple landscape bathed in mist would fill him with delight and send him off in search of his easel.

It is a misty morning in the country. On the right, a huge tree spreads its branches, on the left, a more slender one offers a flowering cluster of leaves. A young girl and two children are busy picking some sprays. Who are they? It is of no importance! Corot didn't attempt to paint their faces. It was the movement of their bodies that interested him, the way they blended with the landscape and gave it life.

a landscape bathed in silvery light

Mortefontaine
Mortefontaine is an immense park near Senlis, in France, that was created in the 18th century. Its forests and lakes have inspired many artists: Corot, of course, but also Watteau, who is said to have derived the setting for *The Pilgrimage to Cythera* from it, and the poet Gérard de Nerval, who situated a part of his novel *Sylvie* at Mortefontaine.

The nearly white light is filtered by the leaves of the large tree whose branches cover the foreground in shadow. Contrary to custom, all of the light is concentrated on the background, shining on the motionless lake that reflects the sky and the trees on its opposite bank. Corot discovered nature very early, in Italy, where painters would go to study the great masters. The Italian light, its "bursting nature", as he called it, was a revelation.
Throughout his life, Corot was to paint landscapes, searching for perfection. When he exhibited *Souvenir de Mortefontaine* at the age of 68, the humorist Gill exclaimed: "Always the same old thing —a masterpiece. What can one expect, that's all Corot knows how to do!"

I've noticed that the first attempt is always the purest and the prettiest in form, and it often contains chance elements that are very effective. Whereas if one works over a painting, it frequently loses that early harmony and freshness.

Jean-Baptiste Corot

what were the colours on Corot's palette?

What is the quietness that emanates from Corot's painting due to? To the peacefulness of the subject, of course, but above all to his use of colour. Corot only used green, blue-gray and white for the landscape surrounding the figures.

the "musician of colour"

Corot's genius lay in the way he brought his landscape to life by playing on colour gradations, softening the darker colours with lead white. He discovered this technique by instinct, for every treatise on painting is against this kind of mixture. And yet, through this method, he achieved perfectly the almost silver light filtering through the leaves.

Souvenir de Mortefontaine, detail. ►

Corot enhanced the overall harmony of the colours with the little touches of pink and red, complementaries of the greens, on the bonnet of the kneeling child and the girl's skirt. These small notes of warm colour were his way of bringing the figures to life without painting them in detail.

Souvenir de Mortefontaine, detail. ▶

Glazing
Corot used layers of tinted glaze, which brought up the background: thus the water appears to be coming through the foliage.

Overlays of paint
In the centre of the canvas, the fine branches of the tree are painted in filigree over the hazy reflections of the lake and the vague shapes in the far distance.

Scumbling
Corot also used the technique of scumbling, which is particularly visible on the trunk of the tree. Scumbling is a thin layer of paint applied closely with an almost dry brush, through which one can see the grain of the canvas.

The touch
One often gets the impression that Corot painted everything with the same light strokes. But he did thicken his brushwork at times, working over a particular area such as the grass with scattered touches of brightness and colour.

Are all of Corot's paintings known?
Corot, like Cézanne and Picasso, didn't always sign his paintings. He considered the signature to be the final touch, but to his way of thinking, a painting was never really "finished". Besides that, he didn't intend that all his works should be sold —he also painted for himself. This is why paintings by Corot are still being discovered to this day.

The dreamlike quality of Corot's painting was due to yet another technique, that of making each layer of paint almost transparent. In this he was imitating Watteau, whose style he much admired.

photographs of the countryside

But there are also those out of focus, dreaming distances. Corot discovered them when he examined the first examples of photography. He was to be fascinated by this new invention and by the end of his life he had collected over 200 photographs of landscapes!

103

to which school of painting did Corot belong?

◀ Jean-Baptiste Corot photographed by Charles Desavary in 1871 or 1872.

Sitting on a painter's stool and sheltered by a large parasol, Corot has been caught "in action". In the paintbox lying on the ground beside him, one can see his materials. What a lot one had to carry with one when painting in the open air! An easel, the canvas on its stretcher, the palette, a multitude of brushes, a parasol, a stool and, of course, the paints themselves, were all indispensible accoutrements.

Was Corot copied?
Few painters, with the exception of Rembrandt perhaps, have been copied as much as Corot. Often the copyist is merely practising, but others are actual forgers. One even finds authentic unsigned Corots bearing a false signature.
Thanks to X-rays, macrophotography and the expertise of art historians, one can now separate the genuine from the forgery.

Let us all go into the great outdoors! In 1800, outdoor painting was officially encouraged. Fired by a passion for absolute reality, painters made detailed sketches in oils, particularly concentrating on the changing effects of light.

in the forest of Fontainebleau

In the 1830's, a group of young painters settled in the village of Barbizon in the forest of Fontainebleau, to study nature. Among them were Corot, Théodore Rousseau, Millet, Daubigny, Troyon, Dupré and Diaz. Each developed his own taste: Rousseau liked sunsets, Millet preferred peasants while Troyon took a great fancy to cows! Corot gave great importance to this painting from life. "One can never overdo the study of nature", he said.

Jean-Baptiste Corot ▶
Volterra (1834).
Oils on canvas:
47 x 82 cm.

Volterra is a small town in Tuscany, Italy, where Corot stayed on three occasions. It was at Volterra that he discovered the effects of light on a landscape.

Corot is associated with the Barbizon school, but he doesn't really belong to it. In fact, he only made oil-sketches and studies in the open air. After that he worked in his studio.

Corot was a nostalgic person

This is why so many of his paintings have the word "souvenir" in their titles. They are paintings of memories that go beyond the depiction of a specific place. With *Souvenir de Mortefontaine,* which he painted when he was over 65 years old, Corot was expressing the sadness he felt as an old man at the sight of youth and Spring.

Corot was not recognized as a major painter by his contemporaries. Only the younger ones, like Berthe Morisot, Camille Pissarro or Sisley really admired him. Corot's discoveries would be their starting point for developing the light that characterized the famous Impressionist movement.

Jean-Baptiste Corot ▶
Diana asleep (1865), detail.
Stumped charcoal on bistre paper enhanced with gouache:
47,5 x 31 cm.

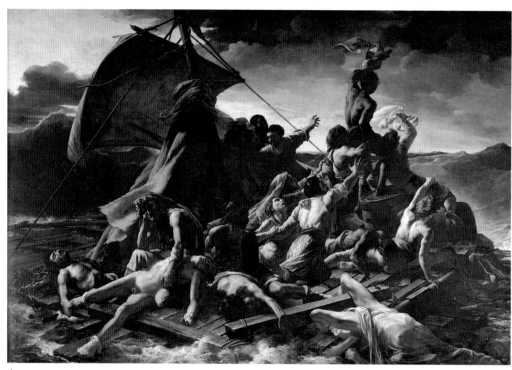

▲
Théodore Géricault,
French painter
(1791-1824).
The Raft of the Medusa
(1819).
Oils on canvas:
height: 4,91 metres,
width: 7,17 metres.
Exhibited at the 1819
Salon, acquired by the
Louvre in 1824.

Théodore Géricault ▶
Painted sketch.
Oils on canvas:
37 x 46 cm.
Unsigned.

Géricault painted
three preliminary
sketches for this work.
This is the first one,
which is very close to
the final painting.
Two of these sketches,
including this one, are
in the Louvre.

GERICAULT
painter of current events

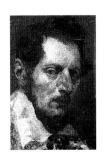

<u>The shipwreck of the frigate *Medusa* at the beginning
of the 19th century shocked and scandalized the whole
of France. Géricault, who had been very moved by the
accounts of the survivors, decided to do an immense
painting of it. It would be his testimonial of the tragedy.</u>

In 1816, a French frigate, the *Medusa*, was on its way
to Senegal. On board there were a number of officials
and emigrants to Africa. On July 2, due to a false
manoeuvre, the frigate was shipwrecked off the coast
of Mauritania. The "officials" and their families took to
the three lifeboats, while the emigrants, 150 people,
were crowded onto a raft 20 metres long and 7 metres
wide. Very soon the lifeboats cast the raft adrift. When
the ship *Argus* came across it 13 days later, 135 people
had died.

murder, suicide and cannibalism

The French government tried to cover up the affair, but
the scandal broke when two of the survivors decided to
publish an account of their adventure. They told stories
of mutiny, suicide, murder and even cannibalism.
Then a young painter of 25, Théodore Géricault was so
impressed by this account that he set off in search of
the survivors and began many months of enquiry.
Which of the many terrible episodes would he paint?
The mutiny on board the *Medusa*? The scenes of canni-
balism? He finally decided to tone down the horror of
the affair and painted the raft at the moment of rescue,
with a ship on the horizon.

**How did the public
react to the
painting?**
When *The Raft of the
Medusa* was exhibited
for the first time, it
shocked the critics,
but it filled the
younger painters with
admiration. Delacroix
exclaimed: "What
hands, what faces!
I cannot begin to
express my admiration
for them!"

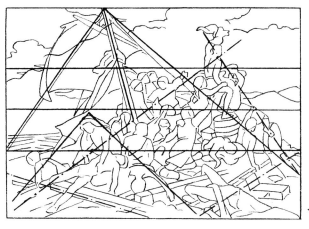

◄ Diagram of the composition

Deciphering a painting sometimes merely requires answering a few simple questions about the composition, the light, the colour and the subject. For this last painting of the book, here is a sort of analytical grid, a series of clues that are possible "keys" to the work.

composition

▧ constructed in a pyramid
▧ rising and descending lines that give the impression of great movement
▧ light coming from the left, with a dramatic use of "chiaroscuro"
▧ colours reduced to a range of earth colours, enhanced with a few touches of red

evolution of the painting

▧ many sketches and studies made
▧ development from the preliminary somewhat realistic cartoon to the more dramatic final painting

models

▧ corpses, the wounded, the dying
▧ survivors

The alteration of the colours
The colours in the painting have darkened over the years, and the areas that the painter worked over the most have crackled. This is because at the time painters used oils that dried quickly but that didn't last; they were cooked with too much lead and therefore had a chemical reaction to the surrounding atmosphere. Black patches gradually form inside the layer of paint, and they are impossible to remove without removing the paint as well!

friends (Delacroix in the foreground with his face to the ground and arms outstretched)

principal actors

a bearded man, symbolizing despair: he is old, his body faces us to show the corpse of his young son in his arms, his eyes are turned away, lost in the past

a black man, symbol of hope: young, with his back turned to us in a yearning movement towards the horizon, he is looking into the distance and faces the future

the figures all communicate with looks or gestures

framing

audacious positioning of the corpse at the lower right, cut off by the edge of the canvas.

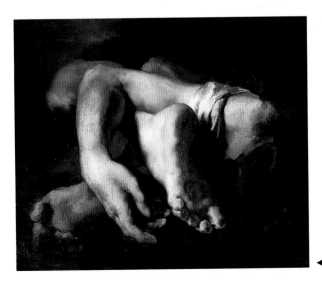

Théodore Géricault
Study of arms and legs (1818).
Oils on canvas: 52 x 164 cm.

Géricault made many sketches of bodies in the morgue of the Beaujon Hospital, which was close to his atelier, in order to make his painting as ◀ realistic as possible.

109

Chronological table

<table>
<tr><td></td><td>13th/14th centuries</td><td>15th century</td><td>16th century</td></tr>
<tr>
<td>RELIGIOUS PAINTING</td>
<td>

CIMABUE
Maestà c. 1300

GIOTTO
St Francis of Assisi c. 1300

Lorenzo VENEZIANO
The Madonna and Child 1372

School of PARIS
The Narbonne High Court altar-frontal c. 1375

Jean de BEAUMETZ
Crucifixion with a Carthusian monk 1389/95?

Jean MALOUEL
Pietà c. 1400

</td>
<td>

FRA ANGELICO
The Coronation of the Virgin c. 1430/35

Jacopo BELLINI
The Madonna and Child adored by Lionello d'Este c. 1450

Andrea MANTEGNA
Crucifixion 1457/60
St Sebastian 1480

Enguerrand QUARTON
The Villeneuve-lès-Avignon Pietà c. 1455

Bernardo MARTORELL
The Flagellation of St George c. 1435

Jan van EYCK
The Madonna of Chancellor Rolin c. 1435

Rogier van der WEYDEN
The Annunciation c. 1435

Flemish artist in Paris
The Paris High Court altar-piece c. 1452

</td>
<td>

Leonardo DA VINCI
The Madonna of the Rocks 1483?
The Virgin and Child with St Anne c. 1508/10
St John the Baptist c. 1513/15

RAPHAEL
La Belle Jardinière 1507
St Michael confounding the Devil 1518

TITIAN
The Entombment c. 1525
Madonna with a rabbit 1530

Paolo VERONESE
The Marriage at Cana 1562/63

EL GRECO
Christ on the Cross adored by donors 1576/79

</td>
</tr>
<tr>
<td>PORTRAITURE</td>
<td>

School of PARIS
Jean II le Bon c. 1350

</td>
<td>

PISANELLO
Portrait of Ginevra d'Este c. 1436/38?

Piero della FRANCESCA
Sigismondo Malatesta c. 1451

Antonello da MESSINA
Il Condottiere 1475

Domenico GHIRLANDAIO
Portrait of an old man and a young boy c. 1488

Sandro BOTTICELLI
Portrait of a young man 1490

Jean FOUQUET
Charles VII, King of France c. 1445
Guillaume Jouvenal des Ursins c. 1460

Hans MEMLING
Portrait of an old woman c. 1470/75

</td>
<td>

Leonardo DA VINCI
Portrait of a Lady of the Court 1497
'La Gioconda', called Mona Lisa 1503/06

RAPHAEL
Balthasare Castiglione 1514

TITIAN
The man with a glove c. 1520/23

Jean CLOUET (?)
François I, King of France c. 1530?

Albrecht DÜRER
Self-portrait 1493

Hans HOLBEIN
Erasmus 1523

</td>
</tr>
</table>

Italy

Low Countries

France

Spain

England

Germany

17th century	18th century	19th century

CARAVAGGIO
The Death of the Virgin 1605/06

Nicolas POUSSIN
The institution of the Eucharist 1640

Francisco de ZURBARAN
The lying-in-state of St Bonaventura c. 1629

Esteban MURILLO
The Birth of the Virgin 1655-58

RUBENS
The Adoration of the Magi c. 1626

Van DYCK
The Virgin with donors c. 1627/30

Jacob JORDAENS
Christ driving the merchants from the Temple c. 1650

REMBRANDT
The Supper at Emmaus 1648
Bathsheba 1654
St Matthew inspired by the Angel 1661

G. PIAZZETTA
The Assumption of the Virgin 1735

G. B. TIEPOLO
The Last Supper c. 1745/50

Pierre SUBLEYRAS
St Benedict bringing a child back to life 1742

Camille COROT
St Sebastian 1850-51

Charles le BRUN
Chancellor Séguier c. 1655/57

Frans HALS
The Gipsy girl c. 1628/30
Paulus de Berestyn 1628

Van DYCK
Charles I of England 1635-38

RUBENS
Helena Fourment with a carriage c. 1639

REMBRANDT
Self-portrait 1660

Hyacinthe RIGAUD
Louis XIV, King of France 1701

J. H. FRAGONARD
Mlle Guimard, dancer c. 1769

Francisco GOYA
The Marquesa de la Solana c. 1793

Thomas GAINSBOROUGH
Lady Alston c. 1760/65

Joshua REYNOLDS
Master Hare c. 1788/89

Jacques-Louis DAVID
Madame Récamier 1800
The Consecration of the Emperor Napoleon 1806/07

J. A. D. INGRES
Mademoiselle Rivière 1806
Monsieur Bertin 1832

Camille COROT
Self-portrait 1805
Maurice Robert 1857
Woman in blue 1874

111

GENRE PAINTING

TITIAN
Le Concert champêtre 1510/11

CARAVAGGIO
The Fortune teller 1594/95

Hieronymus BOSCH
The Ship of Fools c. 1500

BREUGHEL the Elder
The Beggars 1568

STILL LIFES

Italy

Low Countries

France

Spain

England

Germany

17th century	18th century	19th century

Valentin de BOULOGNE
Concert with Roman bas-relief
c. 1622/25

Georges de LA TOUR
The Cheat c. 1635

Le NAIN
The Peasant family c. 1640/45

MURILLO
The Young beggar c. 1650

RUBENS
The Kermis c. 1635
The Tournament

Pieter de HOOCH
A young woman drinking 1658

Jan VERMEER
The Lacemaker c. 1665

G. M. CRESPI
The Flea c. 1720/25

Pietro LONGHI
The Presentation c. 1740

G. TIEPOLO
Carnival scene c. 1745/50

J. B. S. CHARDIN
The Diligent mother 1740
Saying grace 1740

J.-B. GREUZE
The Village bride 1761

J. H. FRAGONARD
The Bathers c. 1772/75

Thomas GAINSBOROUGH
Conversation in a park c. 1746/47

Théodore GÉRICAULT
The Wounded officer 1814

Eugène DELACROIX
The Jewish wedding 1840

J. A. D. INGRES
The Turkish bath 1862

Lubin BAUGIN
Still life with chessboard c. 1630/35
Still life with wafers c. 1630/35

J. J. ESPINOSA
Still life with grapes, birds and shells
1650

Pieter CLAESZ
Still life with musical instruments
1623

Jan FYT
Game and hunting gear c. 1640/50?

Jan DAVIDSZ DE HEEM
A table of desserts 1640

REMBRANDT
The Flayed ox 1655

W. KALF
Still life c. 1660

J. B. S. CHARDIN
The buffet 1728
Still life with jar of olives 1760

J.-B. OUDRY
Bittern and partridge 1747

Corneliss Van SPAENDONCK
Still life with flowers 1789

Luis MELENDEZ
Still life c. 1760/70

Antoine BERJON
Still life with basket of fruits 1814

Eugène DELACROIX
Still life with a lobster 1824/27

	13th/14th centuries	15th century	16th century

HISTORICAL PAINTING

15th century

Paolo UCELLO
The Battle of San Romano 1450/56

Sandro BOTTICELLI
Venus and the Graces offering gifts to a young girl c. 1480/3
(fresco from Villa Lemmi, near Florence)

Andrea MANTEGNA
Wisdom triumphant over the vices c. 1502

16th century

School of FONTAINEBLEAU
Diana, goddess of the hunt c. 1550

Jean COUSIN the Elder
Eva Prima Pandora c. 1550?

Antoine CARON
The Massacres of the Triumvurate 1566

Lucas CRANACH
Venus 1529

LANDSCAPES

Italy

Low Countries

France

Spain

England

114 Germany

Nicolas POUSSIN
The inspiration of the poet c. 1630?
The Rape of the Sabine women 1637

Eustache Le SUEUR
Three Muses c. 1652/55

Charles Le BRUN
Alexander and Porus 1673

RUBENS
Marie de Medici's Gallery 1622/25

J. A. WATTEAU
The Pilgrimage to Cythera 1717

François BOUCHER
Diana bathing 1742

J. L. DAVID
The Oath of the Horatii 1784/85
The Sabine women 1799

Francesco GUARDI
Audience granted by the Doge to the ambassadors in the Sala del Collegio of the Doge's palace c. 1766/70

A.-J. GROS
Napoleon visiting the Plague-stricken at Jaffa, 1799 1804

Théodore GÉRICAULT
The Raft of the Medusa 1819

Eugène DELACROIX
The Death of Sardanapulus 1827

J. A. D. INGRES
The Apotheosis of Homer 1827

Annibale CARRACHI
Hunting c. 1585-88
Fishing c. 1585-88

Le LORRAIN
The disembarkation of Cleopatra at Tarsus c. 1642/43
The Ford 1648

Nicolas POUSSIN
The Four seasons 1660-64
Winter or *The Deluge* 1660-64

REMBRANDT
The Castle 1643

Jan Van GOYEN
River landscape with a windmill and a ruined castle 1644

S. Van RUYSDAEL
The Ray of sunlight c. 1660

Meindert HOBBEMA
The Water mill c. 1660/70?

François BOUCHER
The Forest 1740

Joseph VERNET
View of Naples 1748

P.-H. de VALENCIENNES
Storm at the edge of a lake c. 1782/84

Joseph BIDAULT
Landscape in Italy 1793

Hubert ROBERT
The Pont du Gard 1787
Imaginary view of the Grande Galerie of the Louvre in ruins 1796

J. WRIGHT OF DERBY
View of the Lake of Nemi c. 1790/95

Theodore ROUSSEAU
Group of oak trees, Apremont 1852

Camille COROT
Souvenir de Mortefontaine 1864

C. D. FRIEDRICH
The Tree of crows c. 1822

John CONSTABLE
View of Salisbury c. 1820?

R. P. BONINGTON
The Water-piece at Versailles c. 1826?

J. M. W. TURNER
Landscape with a river and a bay in the background c. 1835/40

Biographical notes

There is
no
known
portrait
of Cimabue

CIMABUE

GIOTTO

▨ Italian painter and mosaicist from Tuscany. His real name is Cenni di Pepe. He was born in Florence *circa* 1240, died in Pisa *circa* 1302.
Little is known about his life, and there is no known portrait of him.

▨ He began his career as a mosaicist, collaborating on the mosaics of the Florence Baptistry.

▨ He painted retables, crucifixes and frescoes. The crucifix painted for the church of San Domenico in Arezzo is one of his earliest works. For the first time, Cimabue painted a suffering Christ, rather than a triumphant one.

▨ In 1272 he stayed in Rome, and then went to Assisi to paint the frescoes in the basilica of San Francesco that were to make him famous.

▨ His other major works are in Florence:
— *Maestà della Santa Trinità* (Uffizi Museum).
— *Crucifix* , church of Santa Croce (before 1288). This crucifix toured Europe in 1982 after its lengthy restoration following the tragic flood of 1966.

▨ Cimabue is also famous for having been the teacher of the brilliant painter Giotto.

▨ Italian painter from Tuscany. His full name is Giotto di Bondone. He was born in Colle di Vespignano *circa* 1266/67, died in Florence in 1337.

▨ He is considered to be the painter who renovated painting, setting it on the path to realism.

▨ He was the pupil of Cimabue, considered at the time to be the most important painter in Europe.

▨ He worked all over Italy: Rome, Assisi, Rimini, Padua and Florence, where he painted some retables and crucifixes. But it was his frescoes that were to make him famous. The major ones are:
— *Scenes from the life of St Francis* (Assisi, basilica of San Francesco).
— *Scenes from the life of Christ* and *Scenes from the life of the Virgin* (*c*. 1303/1305, Padua, Scrovegni Chapel), considered to be his masterpieces.
— *Scenes from the lives of St John the Baptist and St John the Evangelist* (between 1310 and 1312, Florence, church of Santa Croce). In these he experimented with new techniques in the painting of light and colour.

▨ In 1334 he was put in charge of the building of Florence cathedral, to which he contributed the Campanile.

▨ The poet Dante said: "Cimabue believed he was the greatest of the painters, but Giotto has surpassed him."

JEAN FOUQUET

LEONARDO DA VINCI

■ French painter born in Tours *circa* 1420, died there between 1477 and 1481. There is little documentation on his life, but it is known that he made a trip to Italy.

■ During his stay in Rome, he painted a portrait of Pope Eugene IV, which made Fouquet famous in Italy.

■ Back in France he settled in Tours, where the Court resided, and produced:
— illuminations, such as the *Hours of Étienne Chevalier* (before 1461). 40 pages are in the Condé Museum at Chantilly, 2 are in the Louvre.
— retables, such as *Pietà de Noans* (between 1450 and 1460, Noans).
— portraits, such as *Guillaume Jouvenal des Ursins*, Chancellor of France (*c.* 1460, Louvre).

■ Considered the greatest of the French painters in his day, Fouquet was forgotten in the 16th century, and was not rediscovered until the 19th.

■ Italian Renaissance painter of Tuscan origin. His full name is Leonardo di ser Piero da Vinci. He was born in Vinci in 1452 and died in France in 1519, in the town of Amboise.

■ His name is indissolubly associated with the Italian Renaissance and is synonymous with universal genius. He dabbled in everything: architecture, painting, sculpture, music, mechanics, anatomy, botany, optics.

■ He began to write a treatise on painting, the notes for which were gathered together and copied shortly after his death. They demonstrate the complexity of his work. Each of his paintings is a synthesis of his philosophy of life.

■ His career is divided into four periods:
— 1452-1481: in Florence. He entered the atelier of Andrea Verrocchio in 1469. His major work of the period is *The Adoration of the Magi* (1481/82, Florence, Uffizi Museum).
— 1482-1500: first stay in Milan. He painted:
The Madonna of the Rocks, (1483, Louvre). He was to return to the subject in 1506 and paint another version (National Gallery, London).
The Last Supper (1497), a large fresco in the church of Santa Maria delle Grazie in Milan.
— 1500-1516: mature period. He traveled to Mantua and returned to Florence, where he painted the *Mona Lisa* (1503/05, Louvre). In 1506 he returned to Milan and began studying geology. He painted:
The Virgin and Child with St Anne (1510, unfinished, in the Louvre).
St John the Baptist (1513/16, Louvre).
— 1517-1519: He was invited to Amboise by King François I of France, where he is said to have died in his arms.

REMBRANDT

There is
no
known
portrait
of La Tour

GEORGES
DE LA TOUR

▧ Dutch painter of the "golden age". His full name is Rembrandt Harmentzoon van Rijn, which means "near Rijn", a town in the Netherlands. He was born in 1606 in Leden, into a family of well-off carpenters. He died in Amsterdam, poor but famous, in 1669.

▧ Rembrandt worked in every medium: painting, engraving and drawing. In that respect he differed from his contemporaries, who were all specialists (landscape artists, portrait painters, etc.) He produced an immense amount: 300 paintings that are definitely his, almost as many engravings and thousands of drawings.

▧ Today he is considered the greatest Dutch painter of the 17th century. He was one of the first to use the technique of chiaroscuro.
He was a great collector of objets d'art.

▧ His life is divided into four periods:
— 1606-1631: childhood and apprenticeship in Leyden. His major work of this period is:
The Supper at Emmaus (1630, Musée Jacquemart André, Paris).
— 1631-1639: Early years in Amsterdam. He rapidly gained a reputation as a portrait painter. His major work of this period is:
Dr. Tulp's anatomy lesson (1632, Mauritshuis).
— 1639-1650: Mature period. He painted:
The Night watchman (1642, Rijksmuseum).
The Supper at Emmaus (1648, Louvre).
The Castle (1648, Louvre).
—1660-1669: Final years. His major works are:
The Jewish bride (1660, Rijksmuseum).
Portrait of the artist at his easel (1660, Louvre).
The Conspiracy of Claudius Civilus (*c.* 1661/62), a vast work measuring 5 x 5 metres, his last commission.
Simon in the Temple, unfinished, (1669, Stockholm National Museum).

▧ French painter of the 17th century. He was born in 1593 in Vic-sur-Seille in the region of Metz, into a family of bakers. He died in Luneville in 1652, at the height of his career. No letters or drawings by him have survived.

▧ In 1617 he married a noblewoman from Luneville who gave him an elevated position in society. He became "painter ordinary" to the king of France in 1639.

▧ His production comprises 35 original paintings of which only two are signed. He only painted religious and genre subjects.

▧ His works are difficult to date, but they can be roughly divided into two periods:
— up to 1640: daytime scenes with cold, clear light and precise contours.
St Jerome repenting (two versions: one in the Stockholm museum, the other in Grenoble).
The Hurdy-gurdy player (Nantes museum).
The Fortune teller (Metropolitan Museum of Art, New York).
— after 1640: night scenes, lit by artificial light.
Christ with St Joseph in the carpenter's shop (Louvre).
St Sebastian tended by Irene (a gift to Louis XIII, Louvre).
The penitent Magdalen (Louvre).
The Adoration of the shepherds (Louvre).
St Thomas (sold to the Louvre by the Order of Malta in 1988).

There is
no
known
portrait
of Baugin

LUBIN BAUGIN

JEAN-ANTOINE WATTEAU

▦ French painter born *circa* 1610/12 in Pithiviers, died in Paris in 1663. There is little documentation on his life and few of his paintings have been found.

▦ He was probably trained by the Flemish painter Van Boucle at the Confraternity of Saint-Germain-des-Prés. It awarded him the title of "master painter" in 1629.

▦ He stayed in Italy from 1636. He entered the Royal Academy of Painting in 1651.

▦ His work is classified under two subjects and cannot be precisely dated.
— Religious subjects:
The Cathedral of Notre Dame of Paris commissioned eleven paintings of which four have survived.
There are four known *Madonna and Child*, in the Louvre, the National Gallery in London, in the Nancy Museum and the Rennes Museum.
— Still lifes, almost certainly painted before he went to Italy:
The Bowl of fruit (Rennes Museum).
Still life with a candle (Spada Gallery, Rome).
Still life with wafers (Louvre).
Still life with chessboard (Louvre).

▦ French painter born in 1684 in Valenciennes, a Flemish town annexed to France in 1678, which earned him the name of "the Fleming". he died of tuberculosis in 1721 in Nogent-sur-Marne. He spent most of his life in Paris, with the exception of a stay in England from 1719 to 1720.

▦ From 1703 to 1708, he worked in the atelier of the painter Gillot. This was a decisive phase in which he decided upon the subjects he would paint: French and Italian theatre, music, and dance.

▦ In 1709 he became a scene-painter for the curator of the Luxemboug Palace and learned to paint backdrops.

▦ In 1712 he entered the Royal Academy of Painting.

He became famous during his lifetime and those who appreciated his work soon became close friends (the art dealers Sirois and Gersaint, the banker Crozat, the industrial magnate Jean Julienne).

▦ Eight of his paintings are in the Louvre. His masterpieces include:
The Pilgrimage to Cythera (1717, Louvre).
Pierrot, also called *Gilles* (1718/20? Louvre).
The Pleasures of the ball (1716/17? Dulwich Picture Gallery, London).
Assembly in a park (1717/18, Berlin) also called *Récréation galante*.
Gersaint's sign board (1720, Charlottenburg Castle, Berlin), which is a sort of artistic testament.

▦ Forgotten during the Neo-classical period, he was rediscovered by the Romantics. Baudelaire and Verlaine both dedicated poems to him and Balzac, the Goncourt brothers and the historian Michelet all praised his talent.

JACQUES-LOUIS DAVID

EUGÈNE DELACROIX

▨ French painter born in Paris in 1748, died in Brussels in 1825. He painted portraits and historical subjects and dominated French painting for over thirty years. He is considered to be the leader of the Neo-classical school.

▨ He was awarded the *Prix de Rome* in 1774.

▨ He stayed in Italy several times between 1775 and 1780 and from 1784 to 1785.

▨ In 1781 he exhibited one of his first works at the Salon: *Belisarius* (1781, Lille Museum) and opened his Paris atelier, which was to become the major one in Europe.

▨ In 1789 he became a fervent revolutionary. He voted for the execution of the king, became a member of the government and took part in the destruction of the Royal Academy of Painting, which was replaced by the École des Beaux-Arts in 1796. In 1804 he was appointed "principal painter to the Emperor" and commissioned to paint the important moments of Napoleon's consecration as Emperor.

▨ On the restoration of the French Monarchy in 1815, he was exiled to Belgium where he opened an atelier and painted portraits and mythological subjects.

▨ His major works include:
The Oath of the Horatii (1784/85, Louvre).
The Death of Marat (1793, Louvre).
The Lictors bring Brutus the body of his son (1789, Louvre).
Portrait of Bonaparte, unfinished, (1798, Louvre).
The Sabine women (1799, Louvre).
Madame Récamier (1800, Louvre).
The Consecration of the Emperor Napoleon (two versions: one dated 1805, in the Louvre, the other dated 1821, in Versailles).

▨ French painter born in Charenton in 1798, died in Paris in 1863. He came from a bourgeois family related to the family of the cabinet-maker Œben. Number 6, place Furstenberg in Paris, where he died, is now the Delacroix museum.

▨ At the age of 16 he entered the atelier of the painter Guérin. At 17 he went to the École des Beaux-Arts where he came under the influence of the Romantic paintings of Gros and Géricault. He began writing his "Journal" at the age of 24.

▨ He was friends with George Sand, Chopin, and writers Stendhal and Mérimée.

▨ From 1824, he painted historical subjects that he exhibited at the Salons:
—*The massacre at Chios* (1824, Louvre) which depicts an event in the Graeco-Turkish war that took place at that time.
—*The Death of Sardanapulus* (1827, Louvre).
—*Liberty Guiding the people* (1831, Louvre), which is about the Revolution of 1830.
—*The Entry of the Crusaders into Constantinople* (1841, Louvre) which is set in the Middle Ages.

▨ In 1832 a trip to the East inspired a number of paintings:
—*The Women of Algiers* (1834, Louvre).
—*The Jewish wedding* (1841, Louvre).

His works also include some landscapes and studies of animals, particularly lion-hunts.

▨ He was also an interior decorator. He worked on:
—The Salon du Roi and the library at the Palais Bourbon (1833).
—The library of the Luxembourg Palace (1840-1846).
—The central ceiling of the Apollo Gallery in the Louvre (1850).
—The Salon de la Paix of the Paris City-Hall (1852-1854), which was burned during the uprising of the Commune in 1871.
—The Chapel of St Agnes in the Church of Saint-Sulpice in Paris (1849-1860).

JEAN-BAPTISTE CAMILLE COROT

THÉODORE GÉRICAULT

▦ French painter born in Paris in 1796, died in the same city in 1875. He came from a Parisian petty bourgeois milieu and began life as an apprentice draper. At the age of 26 he abandoned this career to dedicate himself to painting.

▦ Drawn to landscape painting, he was initiated in the genre by his friend Michallon. He does not belong to any particular school of painting: he is a Realist in that he made outdoor studies for his landscapes, but also a Romantic because of the melancholy, dreaming atmosphere that impregnates his work.

▦ He stayed in Italy in 1825-28, in 1834 and in 1844. It was there that he discovered light, and made many outdoor sketches in oils such as *The Coliseum* (1826) or *The Trinity of the hills* (1826-28?, Louvre).

▦ He began to become well-known from about 1835, painting mythical landscapes, bible scenes and landscapes peopled by nymphs. He worked a lot in Fontainebleau. From 1850, he painted more and more portraits and group paintings.

▦ His major works include:
Chartres Cathedral (1830, Louvre).
The Toilette (1859, private collection, Paris).
Woman with a pearl (1869, Louvre).
Woman in blue (1874, Louvre).
The young Greek girl (1869, Metropolitan Museum of Art, New York).

▦ He left thousands of paintings. In 1905 an early catalogue itemized 2,500 paintings, to which another 400 works can be added without counting the 600 or more drawings. The Louvre has 125 paintings and the Reims Museum acquired several private collections, but the majority of his paintings are in museums and private collections in the United States.

▦ French painter born in Rouen in 1791, died in Paris in 1824, following a fall from a horse.

▦ A passionate lover of horses, he began his artistic training in the atelier of a painter reputed for his studies of these, Carle Vernet. After that he entered Guérin's atelier, where he learned the techniques used by David.

▦ From 1812 to 1816 he mainly painted military subjects, and had a great success at the 1812 Salon with *Officer of the Imperial Guard charging* (Louvre). Two years later his *Wounded officer of the Imperial guard leaving the Battlefield* (1814, Louvre) was criticised because it was the antithesis of the earlier painting both in its subject and technique.

▦ He stayed in Florence and Rome from 1816 to 1817, where he discovered the works of Michelangelo and Raphael; he also met Ingres, whose drawings he admired.
He painted several studies for a grand composition that he never executed, including *Horse reined in by slaves* (1817, Rouen).

▦ In the autumn of 1817 he returned to his atelier where he began the studies for *The Raft of the Medusa* which he would complete in 1819 (Louvre).
He gradually turned towards subjects of a greater commitment, drawn from current events.

▦ From 1820 to 1821 he stayed in England and discovered lithography. The painting from this period, *The Epsom Derby* (1821, Louvre) was inspired by an 1816 engraving by Rosenberg.

▦ After his death the sale of his atelier dispersed the majority of his work. Far in advance of their times, these works are characterized by their objectivity and audacious techniques. His work is well represented in the Rouen Museum and in the Louvre.

Glossary

Accidental light
A light colour that is reflected in surrounding darker colours.

Aesthetics
The analysis of beauty in art, or a specific concept of beauty.

Asphalt
A transparent dark brown pigment derived from bitumen also known as "smoke brown". It was used especially at the end of the 18th and throughout the 19th Century. Asphalt or bitumen never dries, and often results in an alteration of the painted surface.

Atelier
An artist's studio or workshop in which several assistants or apprentices contributed toward the execution of a work bearing a master's signature, and in which students of art received instruction from the master (see David).

Baroque
The word comes from the Portuguese *barroco* signifying an irregularly shaped pearl. It describes an art marked by a dynamic energy and elaborate forms (see Delacroix).

Canvas
Stiff, tight woven fabric made of linen, cotton or hemp used as a support in painting.

Cartoon
The final stage prior to painting: a drawing generally enlarged from a preliminary study to its full size, outlining the principal components of a composition. Cartoons are usually drawn on paper and then traced onto the support.

Charcoal
Also called fusain, the charcoal pencils or sticks used for drawing are derived from the fusain or spindle tree.

Chiaroscuro
The treatment of a painting in terms of light and shade, especially the use of marked light and shade contrasts.

Classicism
Derived from the Latin *classicus* which means "first class", Classicism was the doctrine of artists who were inspired by Graeco-Roman art, believing it to be universally enduring and valid. The style is characterized by formal elegance and proportion.

Colour grading
The progressive alteration of the luminous intensity of a colour. A colour can be graded through all the values from light to dark. There are also ranges of colours, a range of blues, for example: cobalt, Prussian blue, ultramarine...

Complementary colours
The theory of complementary colours in painting is that the effect of a primary colour will be heightened when it is placed next to the two others united into their secondary colour. Green is the complementary of red, violet of yellow and orange of blue (see Cimabue).

Composition
The placing of the components of the subject of a painting. It is this disposition of the people, architecture, etc., that gives the painting its structure.

Distemper
A process of painting on plaster walls and ceilings in which the pigments are mixed with an emulsion of egg-yolk, with white of egg (see "tempera") or, more usually, with size. Also called size-painting.

Easel
(see Rembrandt).

Fête galante or fête champêtre
A gathering for amusement in a rural setting of members of the 18th Century French court, costumed as shepherds and shepherdesses.

Fresco
The art of painting on freshly spread moist lime plaster with pigments mixed with a water-thinned binding material (distemper, tempera). Fresco has now come to mean any mural.

Genre painting
Paintings that depict scenes from everyday life, usually realistically. Also called Subject painting.

Gesso
A mixture used to prepare walls and wood supports for painting, composed of finely ground gypsum, plaster of Paris, limestone or chalk mixed with a glue and spread in a thin coat over the support. Gesso serves to fill in the irregularities of a wood surface.

Glaze
A thin layer of transparent colour applied at the end of the painting process, to modify the colours and to achieve depth and transparency. The same effects are often achieved by using a lightly tinted varnish (see Delacroix, Rembrandt, Corot).

Gouache
Water dissolvable paint whose pigments have been ground in water and mingled with a preparation of gum. Gouache differs from watercolour by the opacity of its colours, enabling them to be easily painted over.

Ground
Protective coating or preparation that separates the support from the painted parts (see "gesso", "priming").

Gum arabic
A gum extracted from the Acacia. Gum arabic is used to bind watercolours, gouaches and pastels.

Hue
Word used to describe a colour that is made by mixing colours from the spectrum, and especially the gradation of colour.

Iconography, Iconology
(see Baugin).

Medium
Any liquid (turpentine, water, etc.) used to dissolve or thin paint to enable it to be easily applied with a brush. The quantity used of the medium determines the thickness of the paint.

Modelling
To give a three-dimensional appearance and create the illusion of volume on a flat surface by subtly grading the colours, and especially by the use of chiaroscuro.

Mounting
This is done to a fine supple support. Using a strong glue, it is attached to a generally stiff backing.

Mythology
The word is derived from the Greek *mythos*: fable and *logos*: knowledge. Greek myths are fantastic stories about their gods and heroes.

Neo-classicism
An artistic and literary movement of the 18th and 19th centuries that revived the styles of classical antiquity (see David).

Oil (paint)
Paint made of ground pigments, bound with a quick-drying oil and vehicled with a volatile medium, generally turpentine. Oil paints can be used on any support that has been suitably primed and takes a year to dry fully (see Fouquet).

Painting
A painting is made up of four essential components: the support, the ground, the painted parts and the varnish. The painted parts carry the pictorial design, and comprise the preliminary outline or cartoon and all the painting done with the pigment, binder and medium, including the primer coat, the modelling, the colouring, the final modelling and the glaze.

Palette
(see Rembrandt).

Pastel
A stick of coloured chalk. Pastels are made of powdered colours and ground white chalk mashed into a paste with glue or gum arabic. The word also describes a drawing done in pastels.

Patina
The effect of a slow natural evolution of the painting materials that results in a slight darkening of the tones. The patina is produced by the oxidizing of oil-based bindings and the original varnish. Patina is not to be confused with the yellowing of varnishes.

Pentimento
Alterations made to a work in progress by the painter himself. The altered parts frequently become visible after a lapse of time (see Watteau).

Pigment
The basic ingredient of a colour. Whether organic (earth), inorganic (mineral or chemical), pigments are ground to a fine powder, bound with oil or glue and thinned with turpentine or water before being used in painting.

Predella
A secondary painting constituting a border or other appendage to a principal one. Predella is also often used as a synonym for "retable".

Primary and secondary colours
In the six colours of the spectrum, the three primary colours (red, yellow and blue) are not derivable from other colours and form the basis of every hue. The three secondary colours (green, purple and orange) are formed by mixing two primary colours in equal quantities.

Primer coat
A first coat of diluted paint uniformly applied to the canvas during the process of roughing out a painting.

Priming
A layer of a preparation such as size mixed with a pigment spread over the canvas to be used for a painting in order to give it an even surface and prevent the paint from soaking into it. The priming can be white or tinted, smooth or granulated.

Pure colours
Colours that closely approximate the colours of the spectrum. The word is also used to describe a colour applied to the can-

vas "straight from the tube", that is to say, without being previously mixed on the palette.

Red bole
A natural clay used as a ground for gold leaf work. Also known as Armenian bole (see Giotto).

Retouching
Alterations made to a work by a hand other than the painter's. (see Watteau).

Rococo
Rococo is a style that developed in 18th-century France under Louis XV. It is characterized by a fanciful use of flowing, unsymmetrical lines inspired by *rocaille* (artificial rock-work) and pierced shell-work. Rococo also denotes a style of painting especially prevalent at the time, depicting scenes from classical mythology inspired by the *fêtes champêtres* (see Watteau).

Romanticism
A literary and artistic movement that began at the end of the 18th Century as a reaction against Neo-classicism. Romanticism is characterized by the use of dreams or the exoticism of the past, and by the importance given to the individual (see Delacroix).

Sanguine
A pigment usually made of a ferrous oxide called red hematite, which exists in the form of powder, sticks or pastilles in various hues of red. Sanguine also describes the technique of drawing on paper using sanguine or a similar red medium.

Scumble
A thin layer of paint applied closely with fast, irregular strokes and an almost dry brush. Scumbling frequently leaves the grain of the canvas or the preliminary drawing uncovered (see Corot).

Sepia
A pigment of a rich brown colour derived from the ink of the cuttlefish used in drawing inks and watercolour bister. The name also signifies a drawing executed in sepia, especially wash drawings.

Sienna
From Siena where it was first made. An earth pigment that is darker in colour and more transparent in oils than ochre, used both raw and burnt. Raw sienna is brownish-yellow and burnt sienna is reddish-brown.

Sinopia
The name comes from Sinope, an ancient sea port on the Black Sea in Asia Minor, whence it was first imported. Sinopia is a pigment made from a brick red ferruginous clay (sinopite). The name also describes a drawing using sinopia.

Sketch
A rough, free-hand drawing made by an artist giving only the essential features of a subject. These can be quick sketches generally made prior to a cartoon or a study, outdoor sketches or a preliminary layout for a final composition. Sketches are done in pencil, pen and ink or paints.

Stippling
Applying unadulterated colours onto the canvas using small touches to blend them, rather than more traditionally mixing them on the palette beforehand (see Delacroix).

Stretcher
(see Rembrandt).

Study
A drawing or painting intended as a detailed outline, that is made just before the painting proper is begun. The painter would make a number of studies of details for his final composition (heads, groups, draperies, etc.).

Stump
A short thick roll of leather or paper cut to a point used to rub down the lines of a drawing in shading it, or for shading and tinting drawings when using crayon in powder.

Support
The foundation —generally a wall, wood, or canvas— on which a picture is painted.

Tempera
A method of fresco painting similar to distemper, in which the pigments are bound with egg white just prior to use.

Tone
Word used in painting to describe the "lightness" of a colour ranging from very dark to very light. One also speaks of "clear" and "sombre" tones.

Touch
The way in which the paint is applied with the brush. Also means the characteristic skill of an artist apparent in his brush-work (see Watteau).

Treatment
The specific manner or style in which an artist paints a painting (see Rembrandt).

Umber

A brown earth that is darker in colour than ochre or sienna and that is used both raw and burnt. Raw umber is greenish brown and burnt umber is dark brown.

Value

Describes the intensity of a colour in relation to light and shadow. One also speaks of "warm" and "cold" colours.

Varnish

Varnish is obtained by dissolving a natural or synthetic resin in a volatile solvent that when spread upon the surface of a painting dries by evaporation. Varnish serves both to finish a painting and to protect it from the atmosphere.

Varnishing day

The day before the opening of an exhibition, reserved for the painter to varnish or put finishing touches to his work. Nowadays this also describes a reception given on that day, as a preview to an exhibition.

Verdaccio

A green colour popular in late medieval Italy for fresco painting, especially for the painting of flesh. Verdaccio was a mixture of burnt sienna, ochre, charcoal black, chalk and raw umber (see Cimabue).

Wash

Method of drawing or tinting a drawing by "washing" it with highly diluted Indian ink or any other water-vehicled pigment.

Watercolour

Water dissolvable paint whose pigments are bound with gum arabic. Watercolour is more transparent than gouache.

White lead

(see Corot).

Zinc white

Zinc oxide that is the whitest of all pigments and does not yellow, but lacks the covering power of white lead. In use since 1840, zinc white is comparatively cheap and non-poisonous.

Photographic credits

Contents

Edited by Scorpio
Lay-out by Maxence Scherf
Illustrations by Philippe Mignon
Designer : Dominique Guillaumin
Color separation : Reproduzione Scanner
Printed by Editoriale Libraria, Italy
Dépôt légal : March 1994